Pro·Lighting

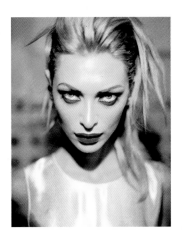

FASHION SHOTS

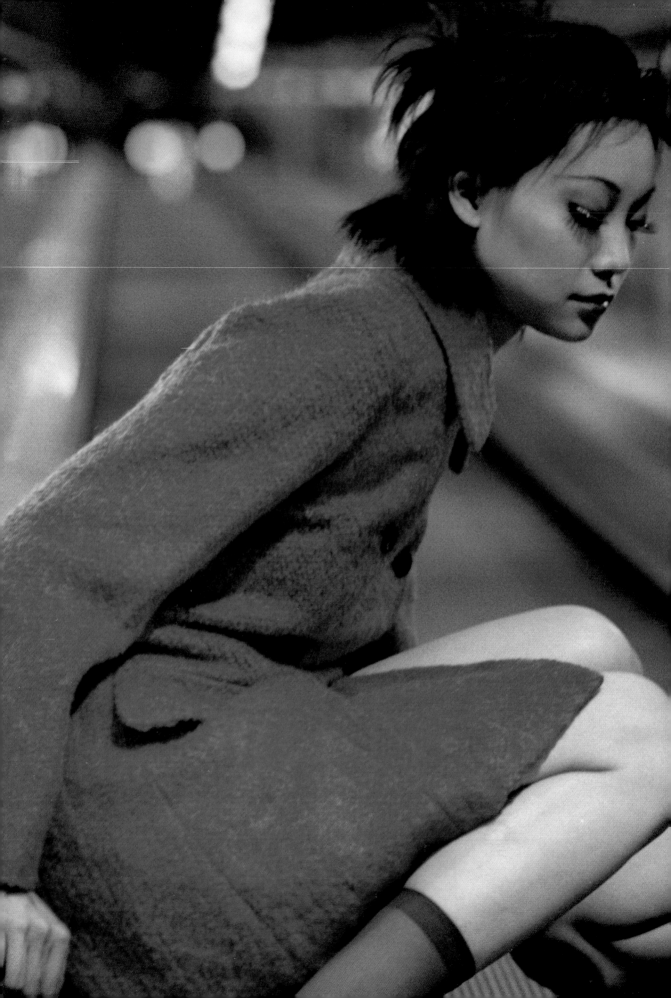

Pro·Lighting

ALEX LARG and JANE WOOD

FASHION SHOTS

RotoVision

A Quintet Book

Published and distributed by
RotoVision SA
Rue du Bugnon 7
CH-1299 Crans-Près-Céligny
Switzerland

RotoVision SA Sales & Production office
Sheridan House
112/116A Western Road
Hove, East Sussex BN3 1DD, UK
Tel: +44 (0)1273 72 72 68
Fax: +44 (0)1273 72 72 69
e-mail: sales@RotoVision.com

Distributed to the trade in the United States by
Watson-Guptill Publications
1515 Broadway
New York, USA. NY 10036

1 3 5 7 9 10 8 6 4 2

ISBN 2-88046-372-6

This book was designed and produced by
Quintet Publishing Limited
6 Blundell Street
London N7 9BH

Creative Director: Richard Dewing
Art Director: Clare Reynolds
Designer: Keith Bambury
Project Editor: Keith Ryan
Picture Research: Alex Larg, Jane Wood, Keith Ryan,
Victoria Hall

Printed in Singapore
Production and Separation by ProVision Pte. Ltd.
Tel +65 334 7720
Fax +65 334 7721

CONTENTS

THE PRO-LIGHTING SERIES

The most common response from the photographers who contributed to this book, when the concept was explained to them, was "I'd buy that". The aim is simple: to create a library of books, illustrated with first-class photography from all around the world, which show exactly how each individual photograph in each book was lit.

Who will find it useful? Professional photographers, obviously, who are either working in a given field or want to move into a new field. Students, too, who will find that it gives them access to a very much greater range of ideas and inspiration than even the best college can hope to present. Art directors and others in the visual arts will find it a useful reference book, both for ideas and as a means of explaining to photographers exactly what they want done. It will also help them to understand what the photographers are saying to them. And, of course, "pro/am" photographers who are on the cusp between amateur photography and earning money with their cameras will find it invaluable: it shows both the standards that are required, and the means of achieving them.

The lighting set-ups in each book vary widely, and embrace many different types of light source: electronic flash, tungsten, HMIs, and light brushes, sometimes mixed with daylight and flames and all kinds of other things. Some are very complex; others are very simple. This variety is very important, both as a source of ideas and inspiration and because each book as a whole has no axe to grind: there is no editorial bias towards one kind of lighting or another, because the pictures were chosen on the basis of impact and (occasionally) on the

basis of technical difficulty. Certain subjects are, after all, notoriously difficult to light and can present a challenge even to experienced photographers. Only after the picture selection had been made was there any attempt to understand the lighting set-up.

This book is a part of the fifth series: EROTICA, FASHION SHOTS and NEW PRODUCTS SHOTS. Previous titles in the series include INTERIOR SHOTS, GLAMOUR SHOTS, SPECIAL EFFECTS, NUDES, PRODUCT SHOTS, STILL LIFE, FOOD SHOTS, LINGERIE SHOTS, PORTRAITS, BEAUTY SHOTS, NIGHT SHOTS and NEW GLAMOUR. The intriguing thing in all of them is to see the degree of underlying similarity and diversity to be found in a single discipline or genre.

Erotica features the entire range of erotic imagery, from fetish to fashionable, from the particular to the general, from subtle suggestion to overt sexuality. Fashion Shots examines the implications this fickle and ever-changing subject can have on photography. Fashion changes with each passing year and each trend changes the images being sold, as this collection of photographs reveals. New Product Shots takes on the challenge of commercial photography in all its guises, asking the question: what is

being sold? Is it the image of the product itself? In all three titles, the key is the lighting used, but the set-ups are not the real focus. As always, it is the photographer that takes centre stage.

The structure of the books is straightforward. After this initial introduction, which changes little among all the books in the series, there is a brief guide and glossary of lighting terms. Then, there is specific introduction to the individual area or areas of photography which are covered by the book. Sub-divisions of each discipline are arranged in chapters, inevitably with a degree of overlap, and each chapter has its own introduction. Finally, there is a directory of those photographers who have contributed work.

If you would like your work to be considered for inclusion in future books, please write to Quintet Publishing Ltd, 6 Blundell Street, London N7 9BH and request an Information Pack. DO NOT SEND PICTURES, either with the initial inquiry or with any subsequent correspondence, unless requested; unsolicited pictures may not always be returned. When a book is planned which corresponds with your particular area of expertise, we will contact you. Until then, we hope that you enjoy this book; that you will find it useful; and that it helps you in your work.

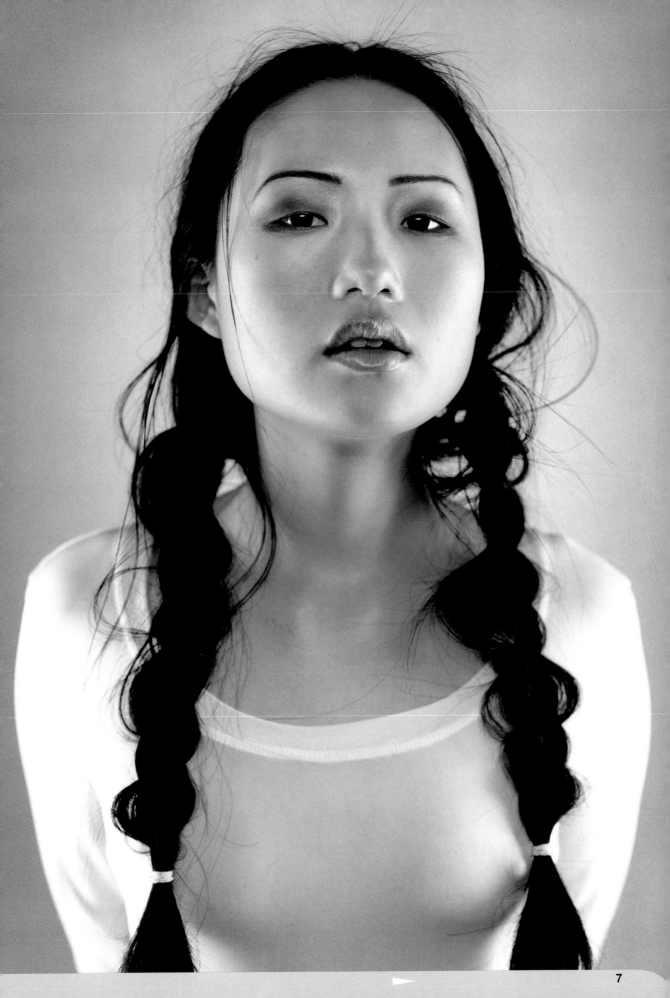

HOW TO USE THIS BOOK

The lighting drawings in this book are intended as a guide to the lighting set-up rather than as absolutely accurate diagrams. Part of this is due to the variation in the photographers' own drawings, some of which were more complete (and more comprehensible) than others, but part of it is also due to the need to represent complex set-ups in a way which would not be needlessly confusing.

Technical information on the equipment used for each picture

Three-dimensional diagrams show how the lighting was set up

Plan views clarify the lighting set up

Bullet points give quick-reference information

Commentary explains how the lighting set up was approached by the photographer

Photographer's personal comment on his or her picture

Full page colour picture of the final image

Distances and even sizes have been compressed and expanded: and because of the vast variety of sizes of soft boxes, reflectors, bounces and the like, we have settled on a limited range of conventionalized symbols. Sometimes, too, we have reduced the size of big bounces, just to simplify the drawing.

None of this should really matter, however. After all, no photographer works strictly according to rules and preconceptions: there is always room to move this light a little to the left or right, to move that light closer or further away, and so forth, according to the needs of the shot. Likewise, the precise power of the individual lighting heads or (more important) the lighting ratios are not always given; but again, this is something which can be "fine tuned" by any photographer wishing to reproduce the lighting set-ups in here.

We are however confident that there is more than enough information given about every single shot to merit its inclusion in the book: as well as purely lighting techniques, there are also all kinds of hints and tips about commercial realities, photographic practicalities, and the way of the world in general.

The book can therefore be used in a number of ways. The most basic, and perhaps the most useful for the beginner, is to study all the technical information concerning a picture which he or she particularly admires, together with the lighting diagrams, and to try to duplicate that shot as far as possible with the equipment available.

A more advanced use for the book is as a problem solver for difficulties you have already encountered: a

particular technique of back lighting, say, or of creating a feeling of light and space. And, of course, it can always be used simply as a source of inspiration.

The information for each picture follows the same plan, though some individual headings may be omitted if they were irrelevant or unavailable. The photographer is credited first, then the client, together with the use for which the picture was taken. Next come the other members of the team who worked on the picture: stylists, models, art directors, whoever. Camera and lens come next, followed by film. With film, we have named brands and types, because different films have very different ways of rendering colours and tonal values. Exposure comes next: where the lighting is electronic flash, only the aperture is given, as illumination is of course independent of shutter speed. Next, the lighting equipment is briefly summarized — whether tungsten or flash, and what sort of heads — and finally there is a brief note on props and backgrounds. Often, this last will be obvious from the picture, but in other cases you may be surprised at what has been pressed into service, and how different it looks from its normal role.

The most important part of the book is however the pictures themselves. By studying these, and referring to the lighting diagrams and the text as necessary, you can work out how they were done; and showing how things are done is the brief to which the Pro Lighting series was created.

DIAGRAM KEY

The following is a key to the symbols used in the three-dimensional and plan view diagrams. All commonly used elements such as standard heads, reflectors etc., are listed. Any special or unusual elements involved will be shown on the relevant diagrams themselves.

THREE-DIMENSIONAL DIAGRAMS

large format camera medium format camera 35mm camera

standard head standard head with barn doors spot

strip soft box light brush

reflector/diffuser/bounce table backdrop

PLAN VIEW DIAGRAMS

large format camera medium format camera 35mm camera bounce

standard head standard head with barn spot gobo

diffuser

reflector

strip soft box light brush backdrop table

GLOSSARY OF LIGHTING TERMS

Lighting, like any other craft, has its own jargon and slang. Unfortunately, the different terms are not very well standardized, and often the same thing may be described in two or more ways or the same word may be used to mean two or more different things. For example, a sheet of black card, wood, metal or other material which is used to control reflections or shadows may be called a flag, a French flag, a donkey or a gobo – though some people would reserve the term "gobo" for a flag with holes in it, which is also known as a cookie. In this book, we have tried to standardize terms as far as possible. For clarity, a glossary is given below, and the preferred terms used in this book are asterisked.

Acetate
see Gel

Acrylic sheeting
Hard, shiny plastic sheeting, usually methyl methacrylate, used as a diffuser ("opal") or in a range of colours as a background.

***Barn doors**
Adjustable flaps affixed to a lighting head which allow the light to be shaded from a particular part of the subject.

Barn doors

Boom
Extension arm allowing a light to be cantilevered out over a subject.

***Bounce**
A passive reflector, typically white but also, (for example) silver or gold, from which light is bounced back onto the subject. Also

used in the compound term "Black Bounce", meaning a flag used to absorb light rather than to cast a shadow.

Continuous lighting
What its name suggests: light which shines continuously instead of being a brief flash.

Contrast
see Lighting ratio

Cookie
see Gobo

***Diffuser**
Translucent material used to diffuse light. Includes tracing paper, scrim, umbrellas, translucent plastics such as Perspex and Plexiglas, and more.

Electronic flash: standard head with diffuser (Strobex)

Donkey
see Gobo

Effects light
Neither key nor fill; a small light, usually a spot, used to light a particular part of the subject. A hair light on a model is an example of an effects (or "FX") light.

***Fill**
Extra lights, either from a separate head or from a reflector, which "fills" the shadows and lowers the lighting ratio.

Fish fryer
A small Soft Box.

***Flag**
A rigid sheet of metal, board, foam-core or other material which is used to absorb light or to create a shadow. Many flags are painted black on one side and white (or brushed silver) on the other, so that they can be used either as flags or as reflectors.

***Flat**
A large Bounce, often made of a thick sheet of expanded polystyrene or foam-core (for lightness).

Foil
see Gel

French flag
see Flag

Frost
see Diffuser

***Gel**
Transparent or (more rarely) translucent coloured material used to modify the colour of a light. It is an abbreviation of "gelatine (filter)", though most modern "gels" for lighting use are actually of acetate.

***Gobo**
As used in this book, synonymous with "cookie": a flag with cut-outs in it, to cast interestingly-shaped shadows. Also used in projection spots.

"Cookies" or "gobos" for projection spotlight (Photon Beard)

***Head**
Light source, whether continuous or flash. A "standard head" is fitted with a plain reflector.

***HMI**
Rapidly-pulsed and

effectively continuous light source approximating to daylight and running far cooler than tungsten. Relatively new at the time of writing, and still very expensive.

***Honeycomb**
Grid of open-ended hexagonal cells, closely resembling a honeycomb. Increases directionality of

Honeycomb (Hensel)

light from any head.

Incandescent lighting
see Tungsten

Inky dinky
Small tungsten spot.

***Key or key light**
The dominant or principal light, the light which casts the shadows.

Kill Spill
Large flat used to block spill.

***Light brush**
Light source "piped" through fibre-optic lead. Can be used to add highlights, delete shadows and modify lighting, literally by "painting with light".

Electronic Flash: light brush "pencil" (Hensel)

Electronic Flash: light brush "hose" (Hensel)

Lighting ratio
The ratio of the key to the fill, as measured with an incident light meter. A high lighting ratio (8:1 or above) is very contrasty, especially in colour, a low lighting ratio (4:1 or less) is flatter or softer. A 1:1 lighting ratio is completely even, all over the subject.

***Mirror**
Exactly what its name suggests. The only reason for mentioning it here is that reflectors are rarely mirrors, because mirrors create "hot spots" while reflectors diffuse light. Mirrors (especially small shaving mirrors) are however widely used, almost in the same way as effects lights.

Northlight
see Soft Box

Perspex
Brand name for acrylic sheeting.

Plexiglas
Brand name for acrylic sheeting.

***Projection spot**
Flash or tungsten head with projection optics for casting a clear image of a gobo or cookie. Used to create textured lighting effects and shadows.

***Reflector**
Either a dish-shaped

surround to a light, or a bounce.

***Scrim**
Heat-resistant fabric

Electronic Flash: projection spotlight (Strobex)

Tungsten Projection spotlight (Photon Beard)

diffuser, used to soften lighting.

***Snoot**
Conical restrictor, fitting over a lighting head. The light can only escape from the small hole in the end, and is

therefore very directional.

***Soft box**
Large, diffuse light source made by shining a light

Tungsten spot with conical snoot (Photon Beard)

Electronic Flash: standard head with parallel snoot (Strobex)

through one or two layers of diffuser. Soft boxes come in all kinds of shapes

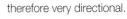

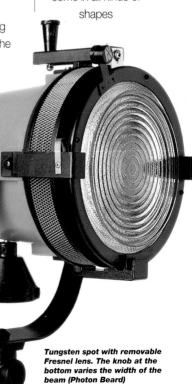
Tungsten spot with removable Fresnel lens. The knob at the bottom varies the width of the beam (Photon Beard)

Electronic flash: standard head with large reflector and diffuser (Strobex)

and sizes, from about 30x30cm to 120x180cm and larger. Some soft boxes are rigid; others are made of fabric stiffened with poles resembling fibreglass fishing rods. Also known as a northlight or a windowlight, though these can also be created by shining standard heads through large (120x180cm or larger) diffusers.

***Spill**

Light from any source which ends up other than on the subject at which it is pointed. Spill may be used to provide fill, or to light backgrounds, or it may be controlled with flags, barn doors, gobos etc.

***Spot**

Directional light source. Normally refers to a light using a focusing system

with reflectors or lenses or both, a "focusing spot", but also loosely used as a reflector head rendered more directional with a honeycomb.

***Strip or strip light**

Lighting head, usually flash, which is much longer than it is wide.

Electronic flash: strip light with removable barn doors (Strobex)

Strobe

Electronic flash. Strictly, a "strobe" is a stroboscope or rapidly repeating light source, though it is also the name of a leading manufacturer:

Tungsten spot with safety mesh (behind) and wire half diffuser scrim (Photon Beard)

Strobex, formerly Strobe Equipment.

Swimming pool

A very large Soft Box.

***Tungsten**

Incandescent lighting. Photographic tungsten

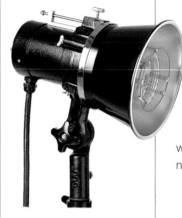

Electronic flash: standard head with standard reflector (Strobex)

lighting runs at 3200°K or 3400°K, as compared with domestic lamps which run at 2400°K to 2800°K or thereabouts.

***Umbrella**

Exactly what its name suggests; used for modifying light.

Umbrellas may be used as reflectors (light shining into the umbrella) or diffusers (light shining through the umbrella). The cheapest way of creating a large, soft light source.

Windowlight

Apart from the obvious meaning of light through a window, or of light shone through a diffuser to look as if it is coming through a window, this is another name for a soft box.

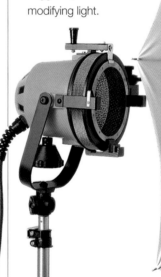

Tungsten spot with shoot-through umbrella (Photon Beard)

FASHION SHOTS

Photography is an ideal medium for the fashion industry to utilise as a publicity machine. Just as fashion is swiftly changing its needs constantly shifting, so the photography industry in parallel can swiftly produce the images needed to keep up with the fashions, giving an immediacy and sense of 'the moment' that is essential in such a fast-moving environment. In many ways the two industries feed off each other. An enormous proportion of commercial photography is, in one way or another, associated with the world of fashion.

Ironically, it is the very accessibility, the ease and swiftness with which images are produced and the ease of mass reproduction of the images, that has been held against photography by some in the struggle for it to be recognised as an art form in its own right. The fact is that photography does seem instant; it is quick and apparently easy to produce an image and anybody can do it. However, not everybody does have the creative vision or the eye for an image that separates the snapper from the masters such as Norman Parkinson and Cecil Beaton.

Working with fashion models

The evolution of the supermodel is a phenomenon heavily dependent on the role of the photographer; many supermodels, indeed, attribute their own breakthrough to success largely to one pivotal photograph, that special one that got them the crucial front cover or campaign. The relationship between certain models and their photographers is legendary, and this provides evidence of the fact that a long-term and good working relationship with a model gives the photographer certain insights and advantages

when on the shoot. It is helpful to have a good rapport and to be attuned in a method of working so that co-operation can be nurtured and cross-purposes can be avoided.

Matters of personality are always going to be important when working closely with individuals, but it is especially important to be aware of the sensitivities of fashion models, whose face is their fortune.

Modelling is an intensely competitive industry, emotions can run high and the potential problems of highly-strung individuals are probably over-exaggerated by an over-excitable press in pursuit of a good story. Reality rarely matches up to these hysterical accounts. There is no real reason to expect more histrionics from a professional fashion model any more than from other kinds of model; indeed, the more experienced the model, the more reliable the photographer can assume they will be during a shoot.

The situation to strive for, as when working with on any other type of shoot, is a clear brief, a good working relationship with the model, and as much clarity of communication on both sides as possible. Professionalism on both sides of the camera is the key.

The team

While some models prefer to do their own make-up, in most cases a make-up artist and stylist will be on hand to ensure that the look is exactly as the client and photographer require. Studio assistants will also be required, especially where the lighting set-up is at all complicated and extra hands and eyes are needed to position gobos, hand-held bounces and props in order to get everything just right. While the camera assistants will be concentrating on the technical aspects of the shoot (such as the positioning of lights, meter readings and exposure control – aperture and shutter speed settings) the photographer will take more of an artistic director role.

The client's representative or representatives will often be a crucial members of the team at the commercial fashion shoot. It may be that the agency and/or the client require art directors and publicity managers to be present to ensure that the look being created is indeed the one wanted for a particular fashion product, and in such situations it is essential that the brief has been thoroughly discussed and agreed beforehand.

As ever, hospitality is a consideration. If the client enjoys the shoot as well as liking the end result it is more likely that they will return to the same photographer again. It is also important to keep the working team well refreshed, since a long shoot can be tiring on both sides of the camera and one cannot afford to have any members of the team flagging with exhaustion. In the case of the model in particular, this is a very important factor.

Cameras, lenses and films

As constant variation in image style and techniques is the key to the fashion industry, it is difficult to generalise about the equipment that is appropriate for the fashion shoot. It is probably true to say that most fashion photographers chop and change between different formats and stocks in order to utilise the different creative qualities of the different formats and films available. One can really only say: it depends. What it depends on is the look that is wanted, what is in vogue at the time, the nature of the product and what the client has in mind. All these factors will play a role in the final decision.

The 35mm camera is very light weight and ultra-fast to work with; a 36 exposure film can be shot in a matter moments, maybe in as little as of 4 or 6 seconds. Medium format (645, 6x6cm, 6x7cm, 6x8cm, 6x9cm) is slightly more cumbersome but is still very quick and easy to use. Motor winders are commonly available for these formats, as are camera movements, and of course the benefit of interchangeable backs are immeasurable. Large format (4x5 inch and 8x10 inch, amongst others) really do need more time but this investment in time is amply rewarded with the potential for crystal-clear images and incredible shadow detail — as well of course as the sheer joy for the enthusiast of those glorious beautiful large transparencies!

Generally speaking, telephoto lenses are used as they give a more flattering look all round. Of course, the implications of this are that more studio space is required for full-length images although less background area is required.

The choice of film stock for the fashion shoot between negative and transparency is very much down to the individual. Transparency film has the general benefit of superior quality but at the expense of a relatively small exposure latitude. But with Polaroid testing and many years of experience this is not a terribly dear price to pay. Negative stock, although theoretically of lower quality than transparency film, does in fact offer a greater degree of flexibility in terms of exposure latitude and tonal renditioning. Some people deliberately choose negative film specifically because of the look of the inferior film quality and this is a valid choice if the circumstances allow for it.

Lighting equipment

A whole plethora of lighting equipment is required for the fashion shoot. Large soft boxes, small soft boxes, several standard heads for lighting the background, accessories such as honeycombs, coloured gels, barn doors, gobos, umbrellas, bounces and panels, white, gold and silver reflectors, mirrors and flags will often be used. Almost by definition the fashion shoot is going to be a model-based shoot and so it is not entirely surprising that the only item of lighting equipment that is not commonly used in a fashion shoot is the light brush, which generally needs a perfectly still subject for an extended period of time; although even so it does serve its purpose periodically.

The flash-versus-tungsten decision will be based on the look that is required and personal preference on the part of the photographer; again there are no hard and fast rules. One reason for preferring electronic flash might be that it has the advantage of lower temperatures and so may help prevent the model — and indeed the whole team and studio — from getting overheated. An advantage of the more physically hot tungsten light, which is in fact traditionally preferred for the fashion shoot, is the aesthetic quality inherent in the continuous source. It is something for the individual photographer to weigh up depending on the particular conditions of a particular shoot.

Studio or Location?

In a fashion show situation, there is no choice but to be on location, and that location will be the venue of the catwalk show. There are implications

to this. For one thing, there will be a considerable amount of ambient lighting from the spot lights in the hall to light the runway, and quite apart from this not being within the photographer's control, there are matters such as flare to be taken into account, and little opportunity to have the space to set up the camera to avoid this. Either will be little elbow room, probably no choice of position or view, not to mention the constant flashes from the sea of cameras of other photographers also attending the show. There is only one attempt at every shot; the show will go on whether the photographer has the image that he wants or not, so speed is of the essence and a sense of anticipation is invaluable. The other implication is of course that the photographer must be ready to shoot a great deal of film in these less than ideal circumstances in to have a good chance of a reasonable number of shots turning out successfully amidst so many uncontrollable factors.

In other situations, a commissioned shoot may take place in the studio or on location. The studio offers the fullest control of the situation, and especially of the lighting, whereas the location may offer a more elaborate set than can be managed in the studio and this may be essential for the particular brief and setting of the shot. The choice of site for the shoot can only be determined in relation to the needs of the final image; whether the setting is significant, what kind of look is wanted, and so on. As a rule of thumb, it is broadly true to say that the more spontaneous kind of 'street' images may well happen more commonly on location, while the more formal cover shot-type images are likely to take place in the studio.

The clothes

In a fashion shoot the clothes are the very raison d'être of the session. It is therefore essential that every detail is right; that the clothes are displayed exactly as the client wants and any important features are noted beforehand so that the photographer has a clear brief on exactly which elements are to be emphasised in the final image.

The assistance of a stylist/costume dresser will be extremely helpful in ensuring that the clothing is worn and presented correctly, that it is pressed and free from specks or flaws, and that replacement items are available in case there are any problems with one particular item in the collection. In cases where a unique designer garment is the subject, it will probably be the case that the designer of the item will be on hand to supervise the wearing and presentation – and safety! – of the clothing. In such cases the designer may be the only person who can decide what to do should any accident or problem arise with the garment; whether to repair or amend the garment, or whether to replace it entirely. Needless to say, when valuable unique items are involved, insurance is even more important than usual!

If the garment is especially unusual in some way it is essential that the photographer has an opportunity before the shoot to become familiar with its particular features and become aware of any peculiarities which might require special treatment during the shoot. This is really no more than normal good practice in terms of making sure at the briefing session is thorough and comprehensive, but it is as well to be aware of the surprises that a designer fashion item can present. It may also be necessary to allow for rehearsal and fitting time for the model who is to work on the shoot so that time is also built in for any adaptations to the garment to take place to allow for particular model height and figure. Good preparation is essential.

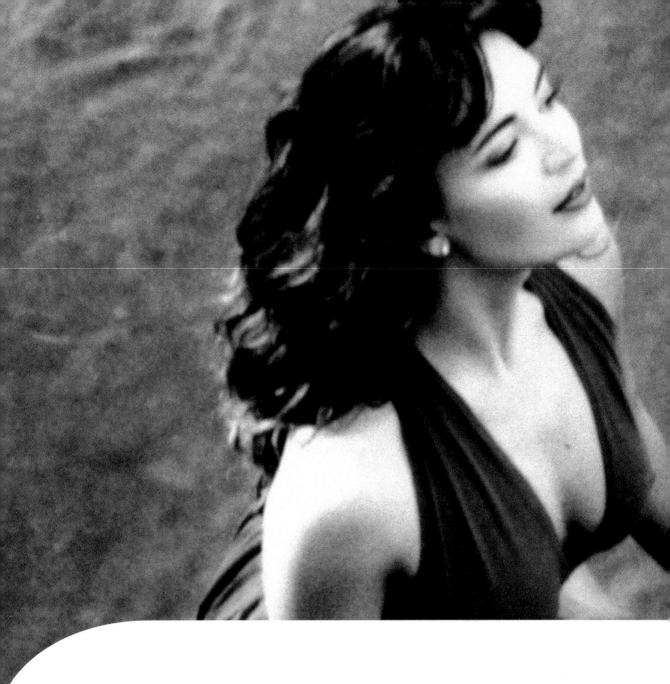

OUTDOOR and LOCATION

01

The possibilities of the many facets of the urban landscape are explored by the photographers whose location work is featured in this chapter. It is interesting that the urban location, with its derelict sites, gritty undergrounds, stark rooftops has been used for what might be described as a hard-hitting yet romantic backdrop to many of these shots. Only in Jörgen Ahlström's "Lisa" is an intrinsically decorative site used, in what might be more conventionally termed a "romantic" setting. The purpose of working on location in a fashion shoot is to lend some atmosphere and context to the element of fashion being promoted. The gritty urban environment is, after all, what many of the consumers of the image will relate to; these images provide a slightly larger-than-life gloss on the familiar for consumers to enjoy.

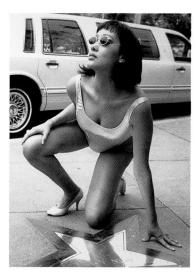

UNTITLED

photographer **Chris Rout**

use	Model portfolio
camera	35mm
lens	200mm
film	Kodak E100S
exposure	1/250 second at f/11
lighting	Available light
location	Garden setting under arch

There is bright sunlight all around, but the model stands under the sole source of shade in this garden location, a decorative stone archway.

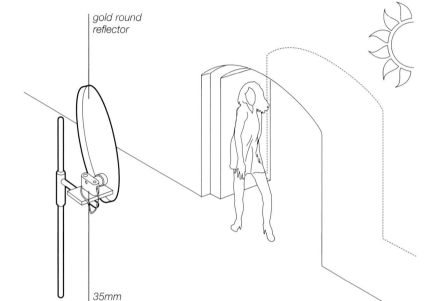

gold round reflector

35mm camera

plan view

key points

On a cloudy day exposure will vary constantly and consistent meter reading is essential for correct exposure

Spot metering will give the correct exposure for a certain area within a scene but bear in mind the contrast ratio when it comes to the background

Selecting a relatively shaded spot within a bright sunny location amounts to creating an on-the-spot studio, al fresco. The shaded archway means that light needs to be introduced for the shot to work, and light added manually is light controlled for the photographer, outdoors as in any studio situation.

In this case, Chris Rout used a large gold reflector to camera left to bounce sunlight from above on to the camera left side of the subject, giving directional golden light down that side of the model, and adding a rich warmth and tanned look to the skin. She thus stands out effectively against the near background of the archway, and the directly sunlit far background is at enough of a distance not to detract from her primary importance in the shot. The shallow depth of field also ensures good separation from the garden background.

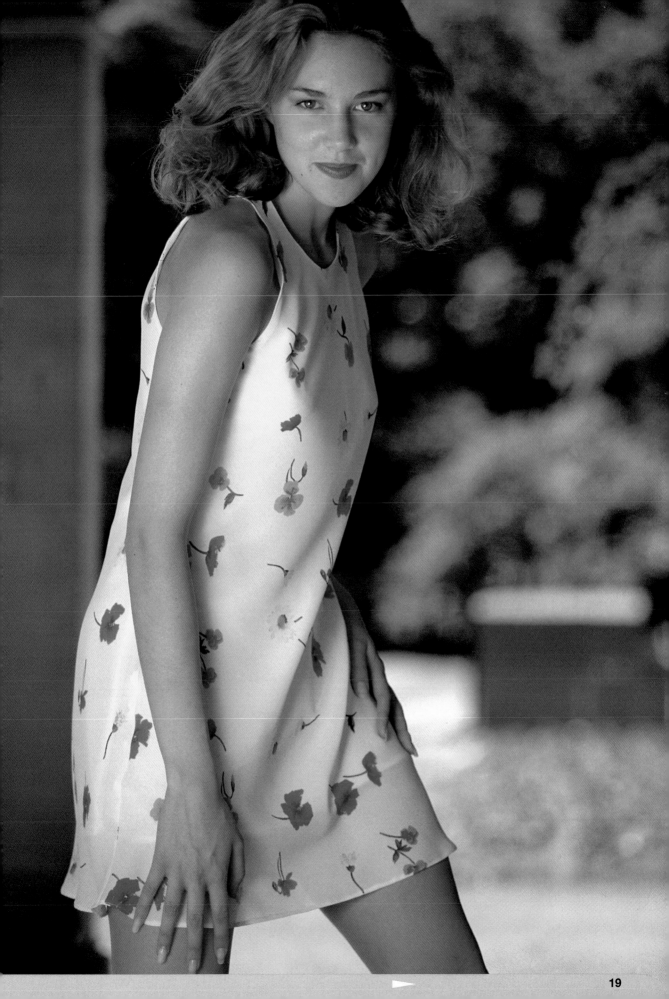

BICYCLE SHOT

photographer **Jeff Manzetti**

client	Madame Figaro
use	Editorial
model	Viola
art director	William Stoddart
hair	Brunno Weppe
make-up	Elsa Auber
stylist	Charla Carter
camera	6x6cm
lens	100mm
film	GPX 400
exposure	f/8
lighting	Available light
props and	
background	Fondation Cartier
	(rooftop terrace)

This shot is a classic example of a photographer using coincidental elements as if they were the closely controlled elements of a studio situation.

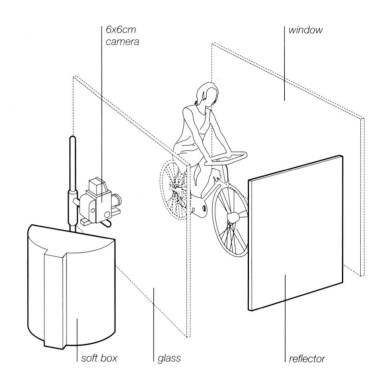

plan view

key points

Reflections in glass can be avoided by use of a polarising filter

It is possible to lose up to 3 stops of light when using a polarising filter so bear this in mind when choosing film stock

Natural sunlight swathes the scene from high overhead; note that such shadows as there are, are very short and give a good indication of the midday position of the sun.

The diffusion material above the camera and model reduces the intensity of the very strong sunlight and a reflector panel in front of the model reduces the depth of the shadows that there are. The foreground glass pane acts as a kind of diffusion filter, slightly softening the image and this is doubly the case for the background, being shot through two panes of glass. A polarising filter was used over the lens to alleviate any reflections in the glass and accentuate the colours.

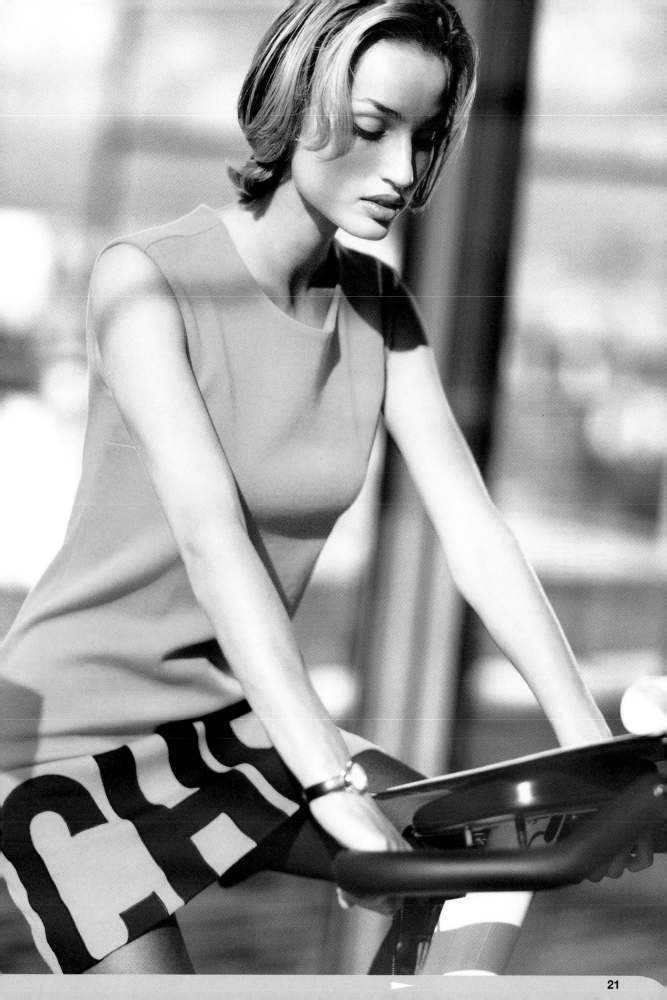

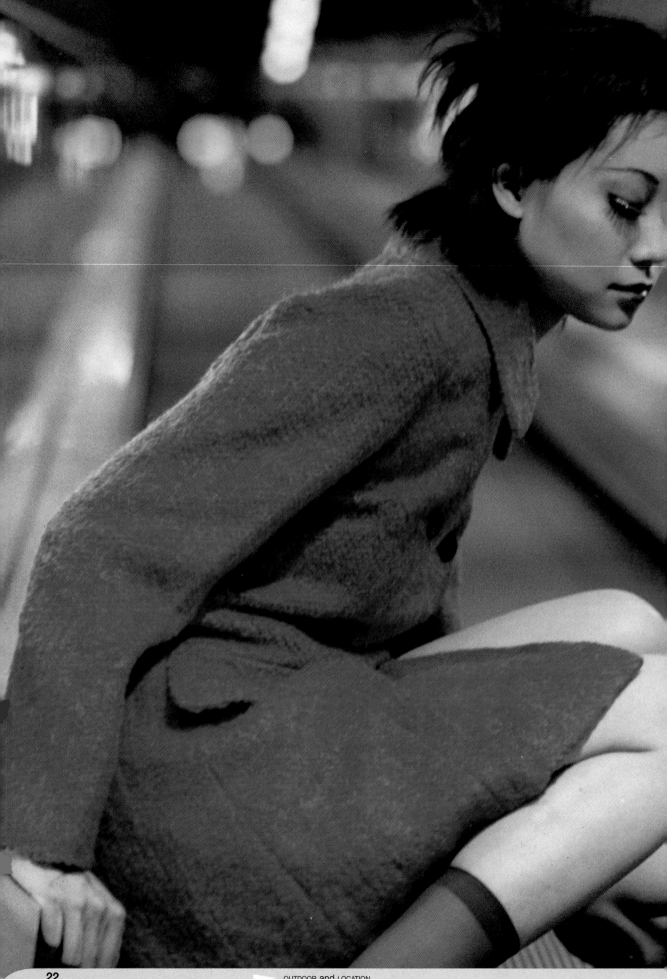

▶ OUTDOOR and LOCATION

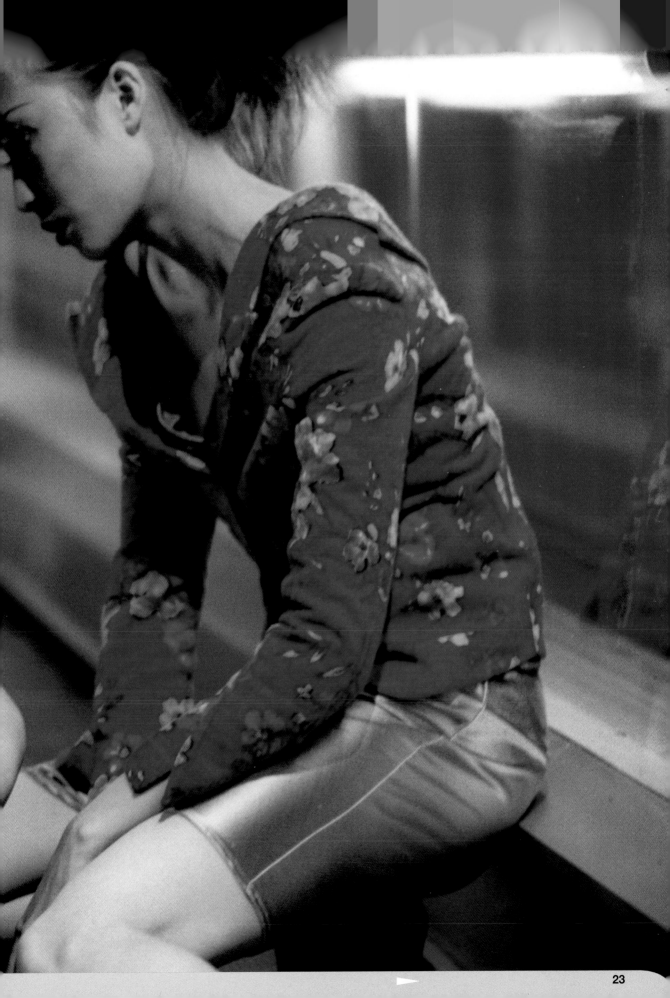

UNDERGROUND

photographer **Wher Law**

use	Personal work
models	Jill and Ann
assistant	K.K. Wong
art director	Wher Law
hair and	
make-up	Chrys Yu
stylist	Eric Lau
camera	35mm
lens	105mm
film	Fuji G800
exposure	1/60 second at f/1.8
lighting	Tungsten, available light
location	Underground escalator

The predominant ambient light in this scene is from the fluorescent tubes under the handrails of the escalator.

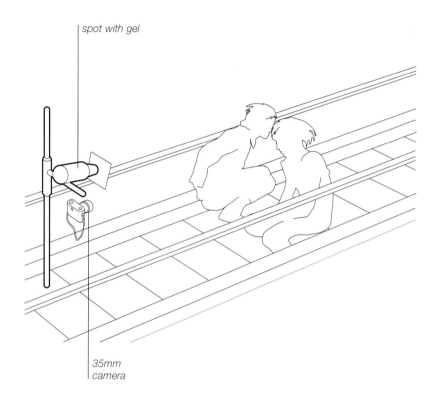

spot with gel

35mm
camera

plan view

key points

A fluorescent to daylight filter can be used to correct fluorescent lighting. It is a purple colour to compensate for the green

Reflections can be controlled by using a polarising filter. It is necessary to use a circular polariser with auto-focusing cameras

Wher Law has not tried to detract from this eerie hue. Instead he has supplemented frontal light in the form of a battery-operated sun gun and modified this with a green gel. A shutter speed of 1/60 second was used to freeze the models and their reflections while still recording background movement that occurs as they travel along on the escalator. The camera is stationary on relation to the models, though not in relation to the surroundings. This is the equivalent of "panning" to follow a speeding racing car.

photographer's comment

Capture the models' feeling, presenting the urban chic. The main light is one stop brighter than the ambient fluorescent light.

STARS WALK

photographer **Ben Lagunas and Alex Kuri**

client	Swimwear Illustrated USA
use	Editorial
model	Viridiana
assistant	Isak, Christian, Paulina, Janice
art director	Alex Kuri
stylist	Stephanie Jones
camera	6x6cm
lens	210mm
film	Kodak Tmax CN
exposure	1/250 second at f/22
lighting	Tungsten, available light
props and background	A stretch limousine

This image was taken on a bright, sunny day with some clouds to diffuse the light.

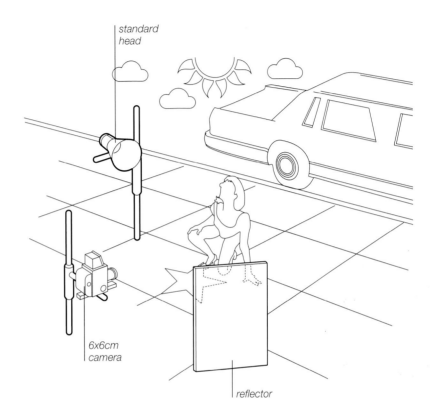

standard head

6x6cm camera

reflector

plan view

key points

The type of film stock used for this image has many advantages. It has massive exposure latitude and can be processed in its own chemistry or standard colour negative chemistry

The warmth in this picture has been introduced by printing on colour paper and using a warm filter combination

Although there is additional artificial light, the key light is the natural source of the sun, and the lighting equipment is used to enhance the sunlight.

The sun keys from behind the model. The tungsten head to the left of the camera adds lift to the unkeyed near side of the model, and the bounce to right provides fill on the shadow side opposite. The brilliant light of the overhead sky provides a high-key background within the mirror-like star so that the reflection of the leg stands out against the reflected sky. The glamour of the setting provides the required mood for showing off the swimwear that is the whole point of the shot.

photographer's comment

This kind of a film allows you to take a black-and-white picture, but you can process it as colour film (C41), giving the possibility of adding colour and warmth within the enlarger using filtration.

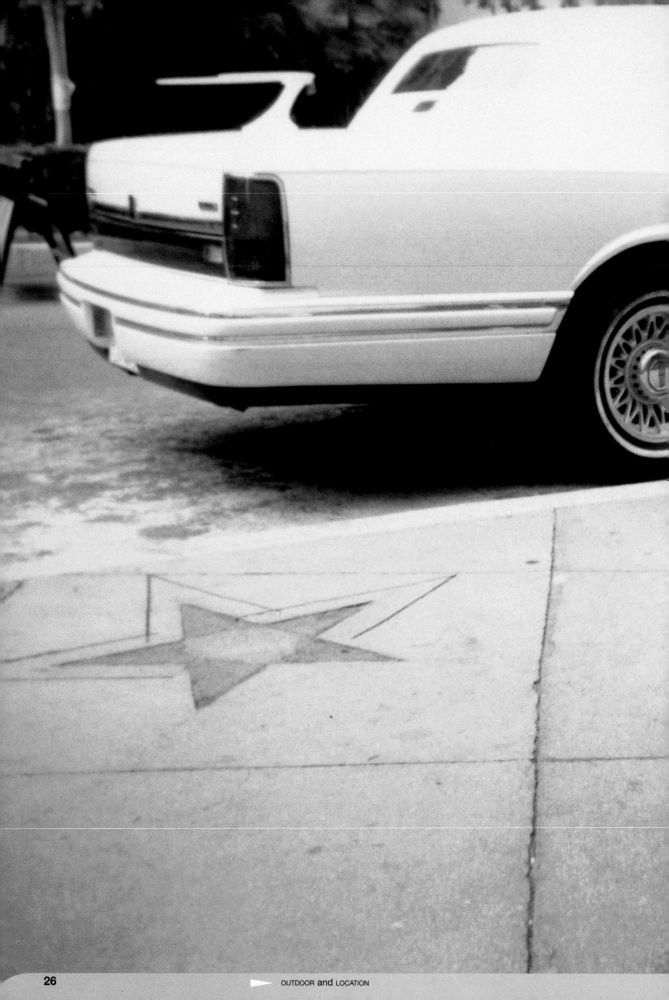

OUTDOOR and LOCATION

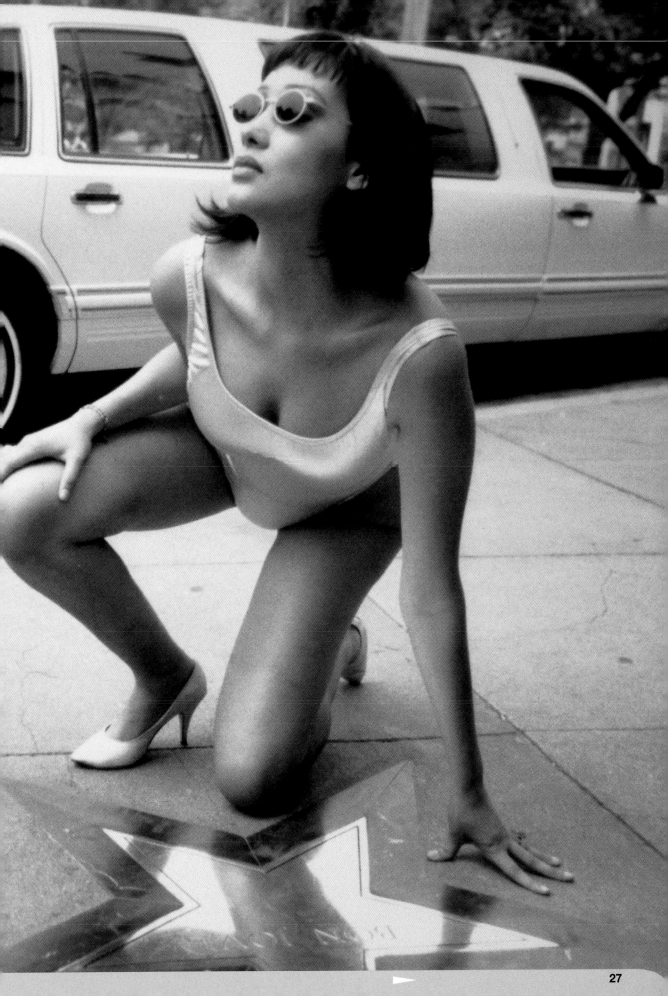

HAND PAINTED DRESS

photographer **Gérard de Saint-Maxent**

use	Editorial
camera	Mamiya 645
lens	55-110mm
film	Tmax 400
exposure	Not recorded
lighting	Available light

The camera was as much as four metres above the model for this shot. The rocky cliff terrain is visible in the outcrop formation in the lower edge of the picture.

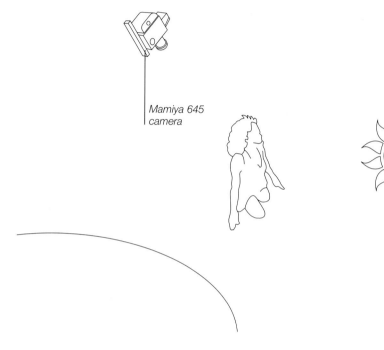

Mamiya 645
camera

plan view

key points

Push-processing black and white film stocks is another method of increasing contrast

Capitalise on naturally occurring reflectors by considered positioning of the model

The model was kneeling on the seashore with her face tilted upwards towards the sun and towards the camera above. Her eyeline, however, is downwards, to protect her eyes from the brilliance of the sun and avoid squinting.

No reflectors were used as this would have undermined the whole effect the photographer was trying to achieve; sufficient fill is provided by the rock faces of the landscape behind the model.

The hard stark high-contrast imagery is a combination of the direct sunlight and the contrasty film stock. To add an extra element of interest, selected areas were finally hand-tinted.

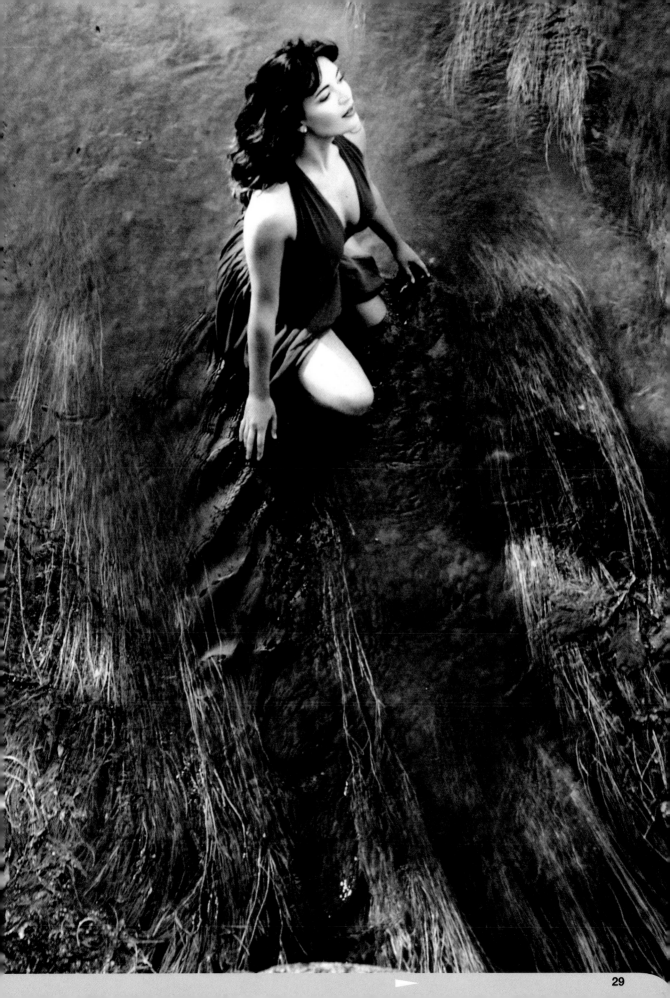

ROOF SWAY

photographer **André Maier**

client	Mode-Info, Berlin
use	Editorial
model	Hila Marin for Next Models
art director	Jörg Bertram
make-up	Hélène Gand
stylist	Jörg Bertram
designer	SWAY
hair	Yoshi Nakahara for Oscar Blandi Salon
camera	6x6cm
lens	90mm
film	Kodak E100SW
exposure	Not recorded
lighting	Available light
props and background	Rooftop, chair found on the roof!

"This was shot on a roof in the East Village, as asked for by the client," says photographer Andrè Maier.

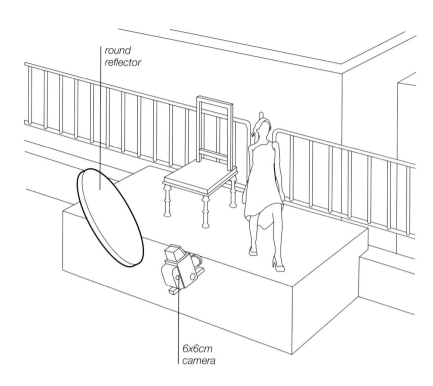

round reflector

6x6cm camera

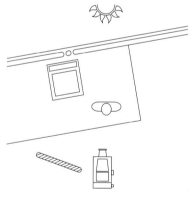

plan view

key points

This image is cross-processed; an E6 film put through a C41 process. The cyan tints to the highlights are classic features of this technique

It is the end look that determines where a meter reading needs to be taken from

"They wanted a 'downtown New York look' for this fashion story on young emerging New York designers." The October day may have been cold for the team to work in, but it also had its advantages: the sky was overcast, and this even cloud cover acts as a huge diffuser, providing even non-directional light across the whole of the subject. The cool sky also provided a smooth, even backdrop against which both the featured fashion item, the modelled dress, and the dark-haired dark-eyed model showed up well. The low angle of the camera is used to make the most of this possibility.

photographer's comment

A long October day; it was cold, the model (and everyone else) was freezing; we had to fit in six outfits from three designers, with three complete hair and make-up changes.

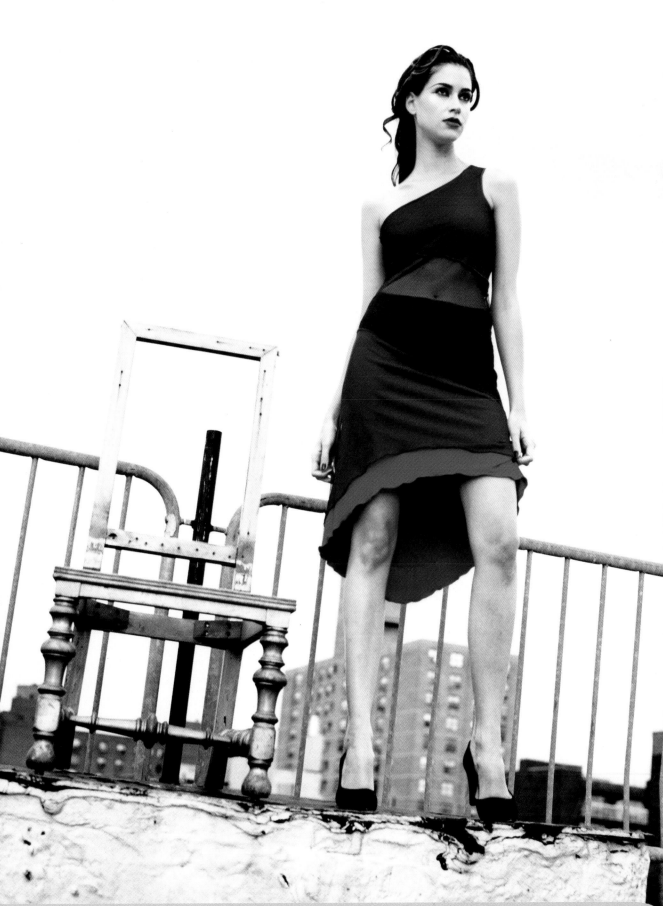

ORANGE TROUSERS

photographer **Corrado Dalcò**

use	Personal work
model	Manici Patrizia
assistant	Matteo Montawari
art director	Corrado Dalcò
camera	Polaroid Instant 636CL
lens	38mm
film	Polaroid 600 Plus
exposure	Not recorded
lighting	Electronic flash
background	Corchia, Italy

A built-in flash can be the simplest of lighting devices to carry about for a location shoot, and in certain circumstances it is as much as you need to get the right look for a shot.

Polaroid Instant 636CL

plan view

key points

A built-in flash allows the photographer to be mobile and adjusting position and view constantly, in the safe knowledge that the lighting will be in a constant position in relation to the lens

On-camera or built-in flash can be modified by gel or tissue paper

Immediacy and spontaneity are often vital ingredients in a fashion shoot to get the model to perform well, to get the shutter snapping and the results flying out of the back or front of the camera with an air of excitement and capturing an "of the moment" look. The Polaroid range of cameras and stock are excellent tools for just these circumstances, coming into their own for a more permanent result than their other major use as a "tester" before the "real thing" is shot on a different format. As Corrado Dalcò shows here, they are more than capable of producing "the real thing".

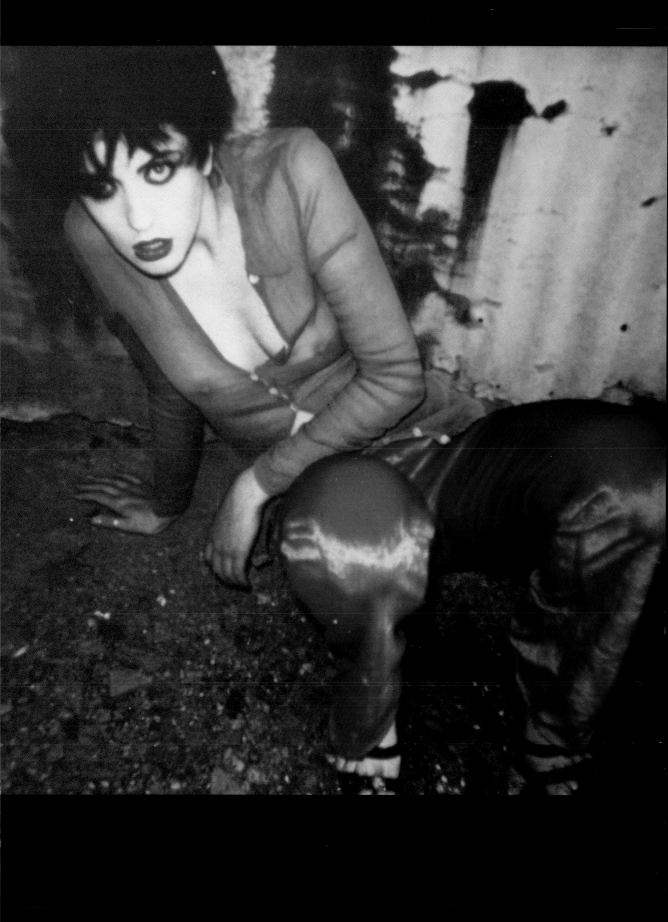

CROCHET OUTFIT

photographer **Frank Wartenberg**

use	Publicity
camera	6x7cm
lens	105mm
film	Fuji Velvia
exposure	1/2 second at f/5.6
lighting	HMI

Frank Wartenberg searched very hard to find this fabulous location.

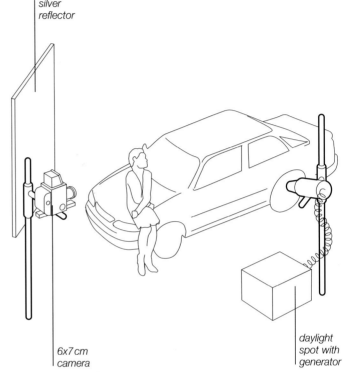

silver reflector

6x7cm camera

daylight spot with generator

plan view

key points

Key lighting from behind is a good way of avoiding inappropriate shadows

When shooting on location it is as well to inform the local police and to be very vigilant of equipment and safety

Of course, if a night shot is what you have in mind, then the locations must be viewed after dusk and when the normal available ambient light is present. In the daytime this scene would look completely different. The HMI, which is three-quarter back lighting the model and car, is the key light in this shot. A large silver reflector opposite the light lifts the near side of the model's costume and the car bonnet.

The daylight balanced key light is deliberately chosen to match with the film stock so that the background ambient light adds warmth.

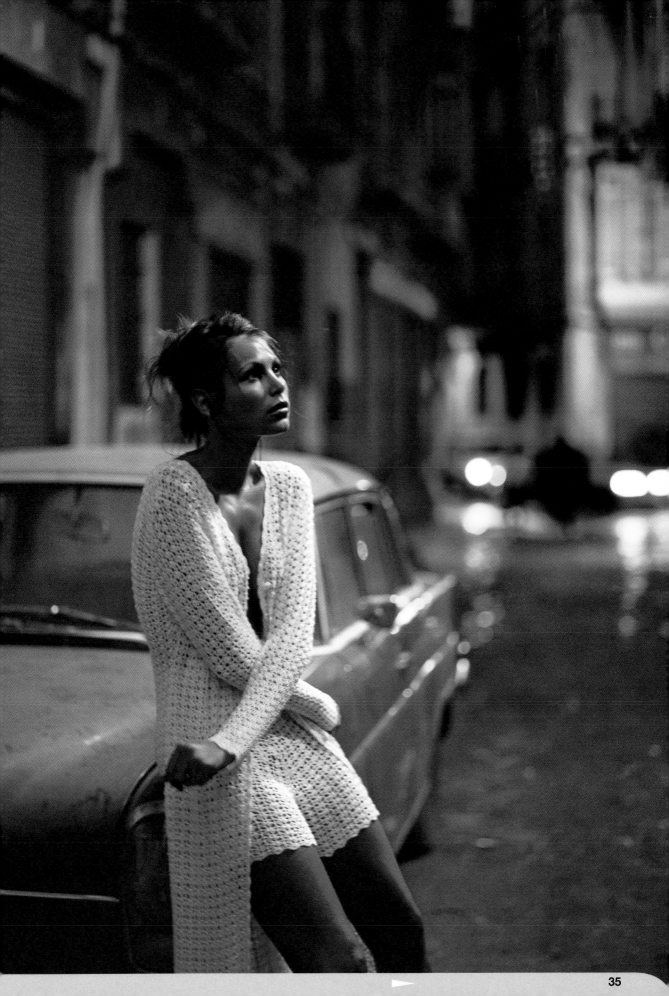

WATER BED

photographer **Jeff Manzetti**

client	Madame Figaro
use	Special beauty editorial
model	Viola
art director	William Stoddart
hair	Brunno Weppe
make-up	Elsa Aubert
stylist	Charla Carter
camera	6x6cm
lens	100mm
film	Fuji EPT 160
exposure	f/5.6
lighting	Available light
props and	
background	Pool

The model is floating in an outdoor pool of water and is positioned directly under a bridge which provides access for the photographer to gain this viewpoint from directly overhead.

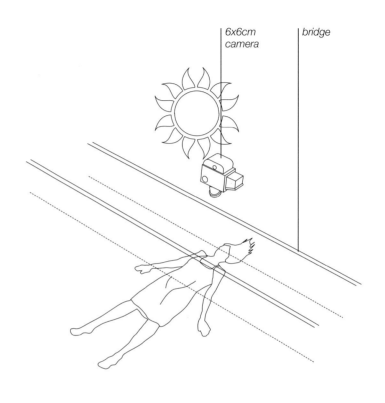

plan view

key points

Controlled use of colour can add to the coherency of a shot

An orange 85 filter will correct tungsten-balanced film for daylight

The shot was taken at midday with the sun at its highest point in the sky giving good overhead light.

The blueness of the pool colour in the rippling water is echoed by the shade of the bathing costume, and taking this thematic use of a colour a stage further, Jeff Manzetti has also achieved blueness in the shadows on the model's body by use of a blue filter combined with a tungsten film; both of which contribute to the blue hue. The skin is so brightly lit by the direct sunlight that it avoids a blue pallor but the shaded areas on the throat, shoulder and arm show the colour quite distinctly.

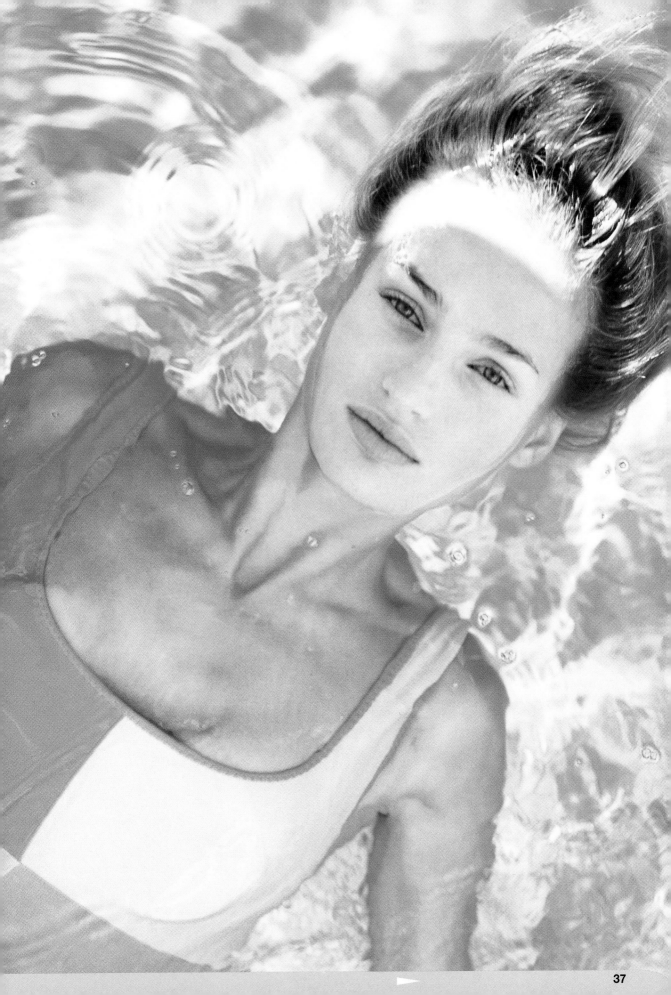

SHADOW

photographer **Craig Scoffone**

client	Fad Magazine
use	Editorial
model	Dawn
camera	35mm
lens	75-125mm
film	Pan-X
exposure	Not recorded
lighting	Available light
props and background	Abandoned industrial site

The long, low shadows of the late afternoon sun have a dramatic impact all of their own.

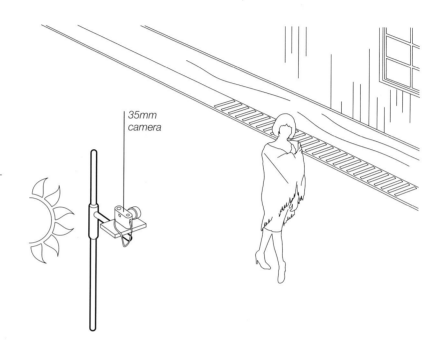

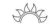

plan view

key points

It is important to get permission to shoot on derelict sites, and possibly inform the police beforehand. Check that there are no guard dogs on patrol which might rudely interrupt the shoot!

It is much more difficult to work with direct hard light than it is to work with soft light, but when it is used well the effect is stunning

In this situation Craig Scoffone has used the difficult direct light on the model's face to emphasise the discomfort that the model is feeling, looking into the sun: her whole pose, body language and expression illustrate this. This is the motivation for holding the shawl protectively to the body.

The sun falls unrelentingly full on the model's face "giving a flat, bright evenness with the features of eyes and lips apparently painted onto a tabla rasa," says Scoffone. "The geometric hairstyle adds to the flat, graphic effect of the head. The modelling and textural interest comes lower down, in the curvature and folds of the shawl and tassels and the highlights in the fabric of the skirt."

photographer's comment

The sun was very near the horizon. This was the last shot of the day. The shadows that were being cast were too dramatic not to incorporate into the final composition.

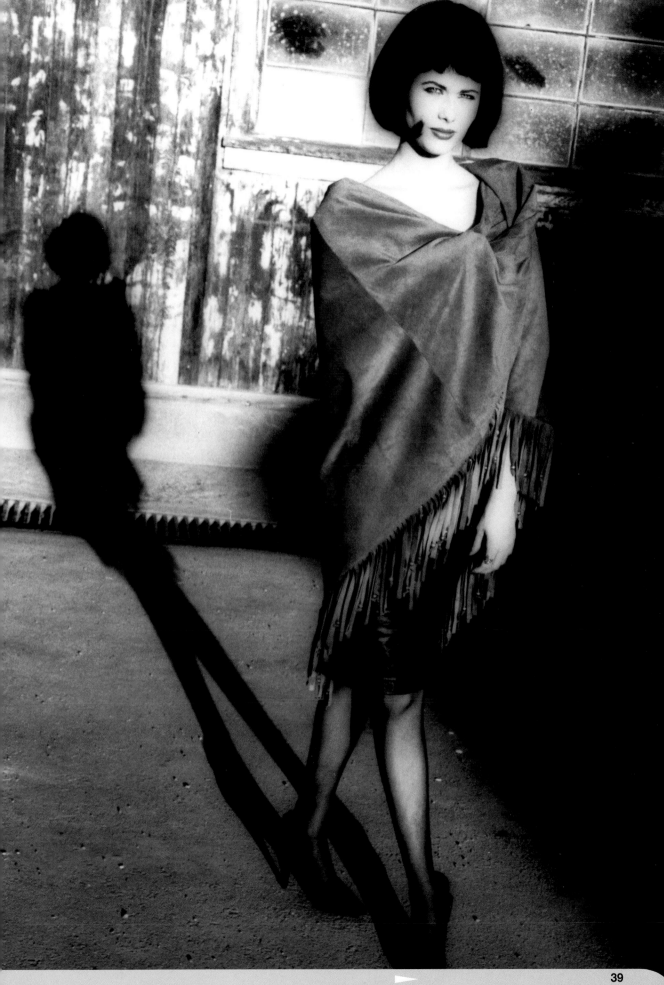

THE CLASSIC LOOK

02

Whether for a cover shot, a fashion editorial or a poster campaign, the "classic look" is that familiar yet undefinable concept that must be all things to all people. Any of the shots in this chapter would not look out of place amongst the pages of the glossy fashion magazines; these are shots that primarily seek to convey the mood, look and style (often more important than the close detail) of a particular fashion outfit, item or even of an entire collection. The classic look shots in general circulation on our news stands and billboards every day need enormous impact yet have an incredibly short shelf-life; very few are destined for any kind of longevity. It is salutary to pause for once, and take the time to look more closely at what it is that makes these shots work.

MAN

photographer **Antonio Traza**

use	Model's portfolio
camera	4x5 inch
lens	210mm
film	Polaroid 55
exposure	1/125 second at f/5.6
lighting	Tungsten
props and	
background	Painted background

Some styles of photography are so distinctive that they are associated with a particular era or look, as in this shot.

plan view

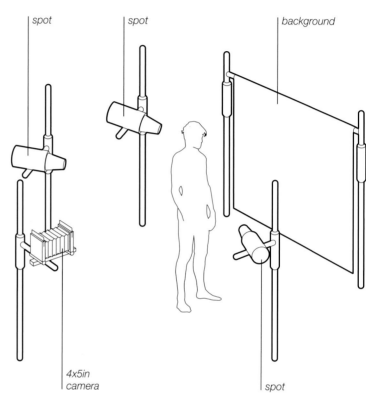

spot spot background

4x5in camera

spot

key points

Rear camera movements are used in this image to make the axis of focus fall along the eye and temple of the model

Polaroid 55 stock is unusual in that it produces a negative as well as a positive

"The choice of lighting was determined by the mood of the picture, looking very much like Hollywood lighting," comments Antonio Traza. "The one-kilowatt tungsten head is very useful because it is not very heavy and the Fresnel glass concentrates the beam of light making an extraordinary tool for focusing the light."

The choice of a model with rugged facial features conjures up the male movie-star image, and the fashion styling is carefully chosen to develop this theme.

Antonio chooses to light the shot with three one-kilowatt heads. One of these illuminates the background. The second keys the model from the right-hand side of the camera, which gives the modelling under the chin. Finally, the third head, which is behind the camera on the left and somewhat further away from the subject, provides fill light.

photographer's comment

In this case, the important elements of the picture were the type of film that was used, which created an unusual border around the negative, and the out-of-focus look obtained by tilting the back of the 4x5 rear panel.

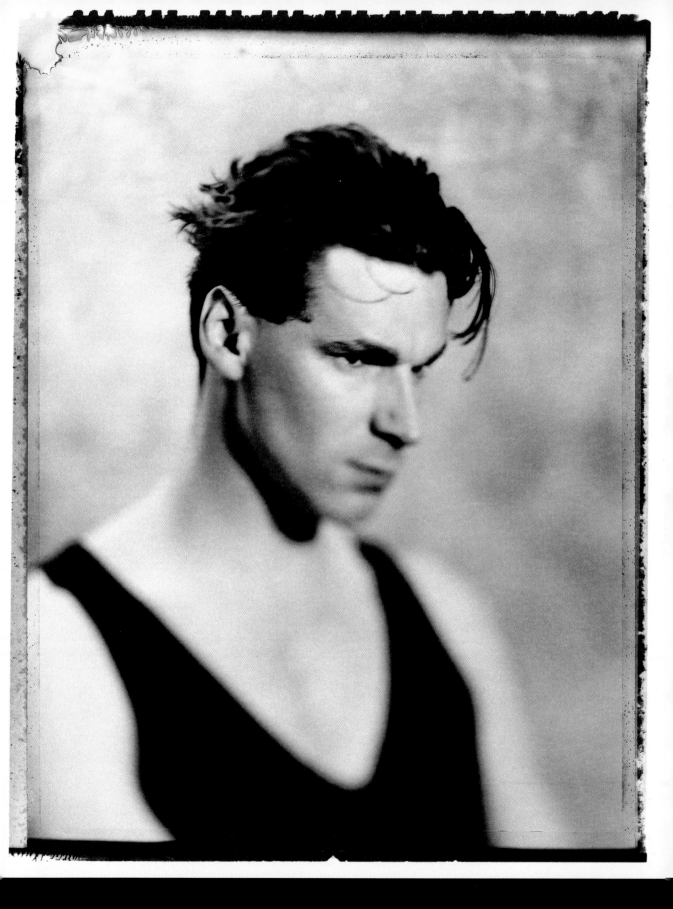

WOMAN

photographer **Antonio Traza**

use	Self-promotion
camera	RZ67
lens	127mm
film	Ilford FP4
exposure	f/8
lighting	Electronic flash

"It is said that if you have a beautiful model to photograph, you already have 95 per cent of the picture done. The other five per cent is the lighting – very easy in this case, just a soft box and a reflector!" quips Antonio Traza.

plan view

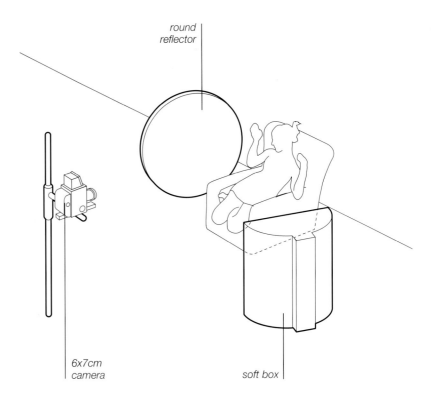

round reflector

6x7cm camera

soft box

key points

It is interesting to note the absence of a catch light. In Hollywood movies, a catch light was often applied by the use of a small light directly above the camera

Indeed, the lighting set-up could not be much simpler. A soft box is placed on the right-hand side of the model and tilted 30 degrees downwards to give top light. A reflector is placed on the left-hand side very close to the armchair to fill in the shadow. The impression is of a woman in pensive mood, sitting in the armchair with the beautiful morning light streaming in through a window. The straightforward, unobtrusive way in which the pose shows off the simple lines of the clothing, within a realistic context, make this a simply classic fashion shot.

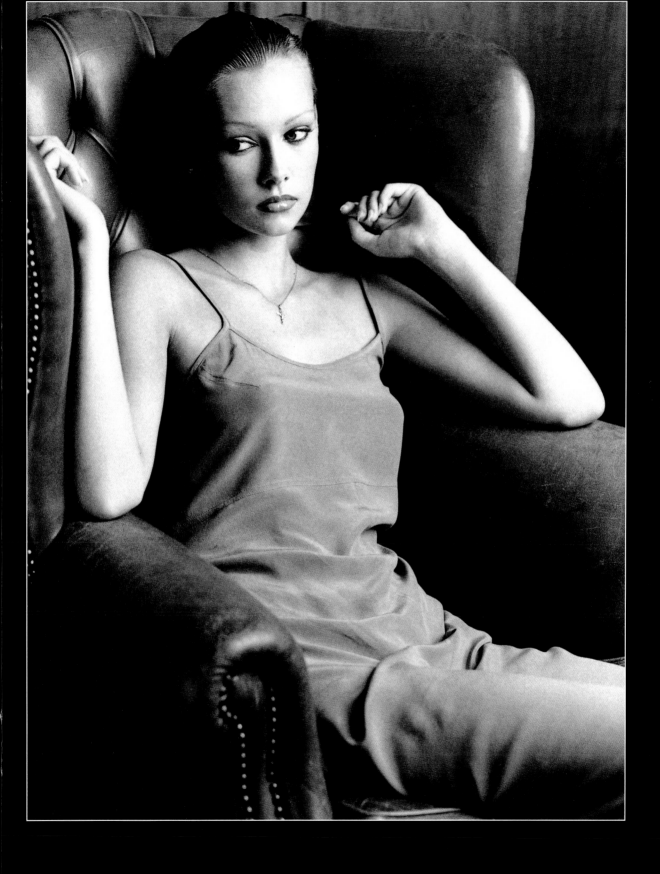

STRAP TOP

photographer **Simon Clemenger**

use	Model portfolio
model	Gurri
make-up	Caroline
stylist	Siobhan
camera	RZ67
lens	50mm
film	Kodak Plus-X
exposure	1/60 second at f/16
lighting	Electronic flash
props and	
background	Blue Colorama

Rim light can add an almost magical quality to a shot when used to good effect. Here it creates a halo for the hair and a silvery definition for the arms.

reflector spot blue background

6x7cm camera

reflector reflector

plan view

key points

It is very important that the flash head is hidden, not only because it is unwanted in the composition, but also because the model's head flags the camera from flare which might otherwise appear as a milky cast across the image

A light grey background can often be preferable to a white background when using black and white stock to reduce the contrast ratio

This effect is especially striking on the model's right arm, where the pose ensures a bold vertical line in contrast with the curved body parts.

A single standard head is placed directly behind the model's head so that she completely obscures the lamp itself. This is what produces the aura-like sparkling rim light around the hair and limbs. There is no frontal light source, but the three large white panels arranged around the camera bounce any available light back onto the face and background. The choice of a blue Colorama background for a black-and-white shot creates an appropriate shade of grey behind the model.

The starkness of the image derives from the way make-up and styling combine with the dramatic lighting. The strong, dark eye make-up gives the model an intensely moody look and sets the atmosphere for the whole shot.

photographer's comment
I metered off a grey scale card in front of the model's face.

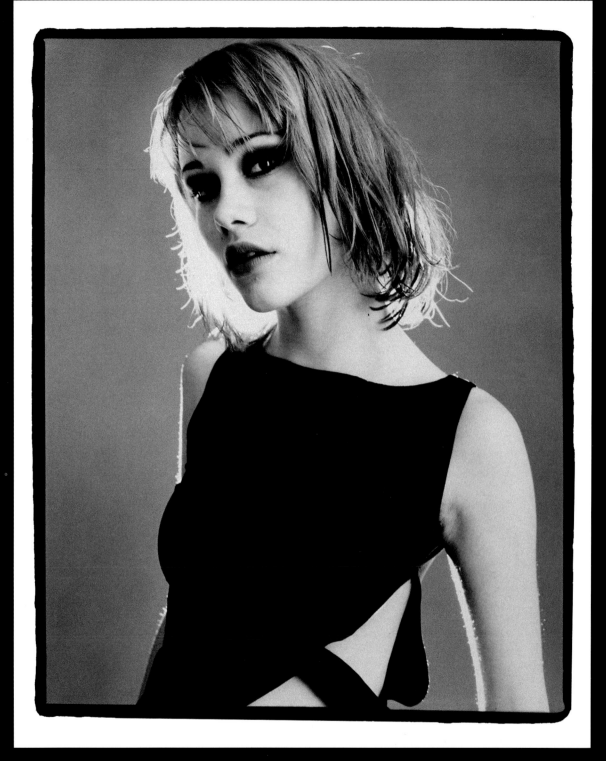

PURPLE VELVET

photographer **Frank Wartenberg**

use	personal work
camera	6x7 cm
lens	90mm
film	Fuji Velvia
exposure	not recorded
lighting	electronic flash
props and	
background	coloured paper background

A pair of soft boxes are placed alongside each other, straight on to the model.

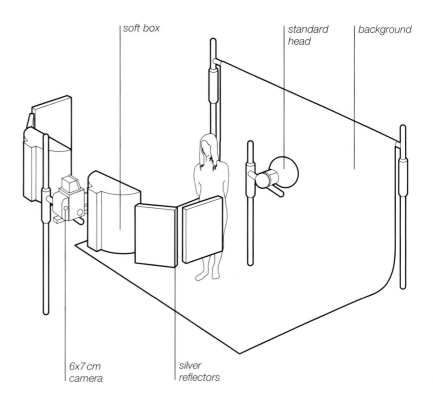

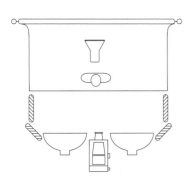

plan view

key points

Honeycombs can be used to make soft light have a degree of directionality

Props and even a model can be used to hide a light source

A wall of silver styro reflectors are arranged into a crescent-shaped wall to either side, and these reflect back the spill light on to the model.

The coloured paper background is lit by a single soft box which is directly behind the model and hidden from the camera's view by her. The even light across the whole subject gives the bright, smooth look to enhance the model's skin, and shows off the velvet of the costume to good effect.

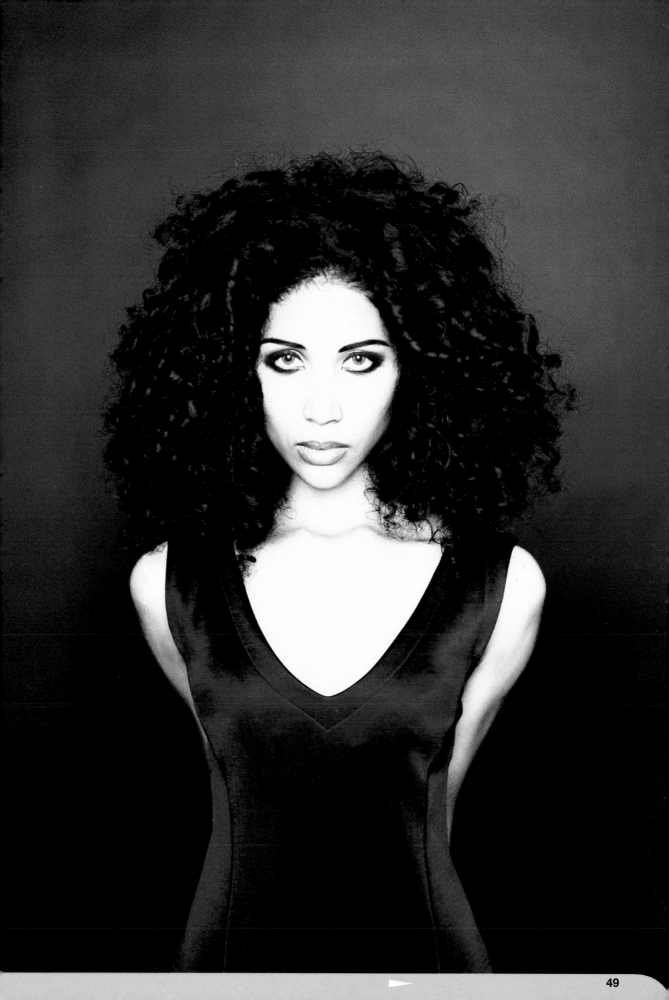

SMILE

photographer **Jeff Manzetti**

client	Grazia
use	Cover
model	Petra
hair	Lucia Iraci
make-up	Michelle Delarne
editor	Stefania Bellinazzo
camera	6x7cm
lens	135mm
film	Fuji EPL 160
exposure	f/4
lighting	Electronic flash

A large assortment of lights contribute to the dazzling look of this beautiful cover shot.

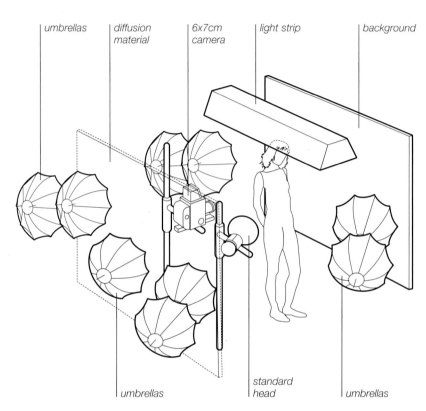

umbrellas diffusion material 6x7cm camera light strip background

umbrellas standard head umbrellas

plan view

key points

The purpose and use for a shot will dictate aspects of the look and technique

Using just a restricted range of saturated colours against a predominantly light or pale background can have a very strong impact on the viewer

The dazzling smile and gleaming complexion are shown to good advantage as they are bathed in an even spread of light emanating from a virtual wall of light in the form of a series of umbrellas arranged in an arc behind and around the photographer. These all shoot through a curtain of diffusion material, softening and evening the effect on the subject. In addition to this is a key light, a daylight-balanced HMI to camera right, which is the only direct light on the model. It is positioned just high enough to give a gentle amount of modelling below the chin.

On the background are four more umbrellas, one pair on either side. The resulting lightness and evenness of a large part of the final image makes a good background against which the necessary cover text can 'read' clearly. A very mottled or light-and-dark image makes it difficult for text to show up well, and this is always a major consideration for a cover shot.

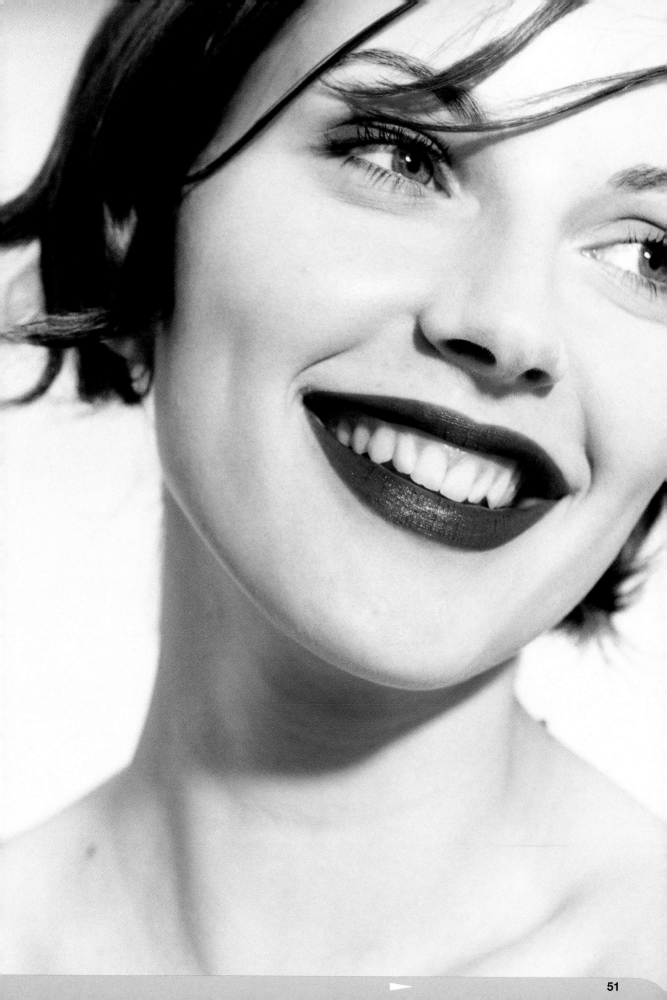

EMMA

photographer **Jörgen Ahlström**

use	Personal work
model	Emma
camera	6x7cm
lens	90mm
film	Kodak PXP 125
exposure	Not recorded
lighting	Available light

Though this may look like a classic studio portrait, it is in fact a location shot.

6x7cm
camera

plan view

key points

Depth of field is dependent on several factors: the proximity of the subject to the camera, the focal length of the lens and the aperture setting

Depth of focus, not to be confused with depth of filed, is located at the film plane

The model is standing in a doorway with a white wall providing a plain background behind her. The photographer is on a balcony a little higher than the model. The sun is to camera left but the position in the location chosen gives a relatively non-directional look as the light is bounced from the building walls and doorways around.

There is a shallow depth of field and the camera is in close proximity to the model to give the soft look to the peripheral areas of the shot with only the detail of the central face (specifically, the eyes and complexion) in sharp focus, to emphasise the model's features and immaculate make-up. There are shapely highlights on the cheekbones but the make-up ensures that these do not register as an unflattering shine. Instead the make-up maintains a perfect gleaming matt complexion.

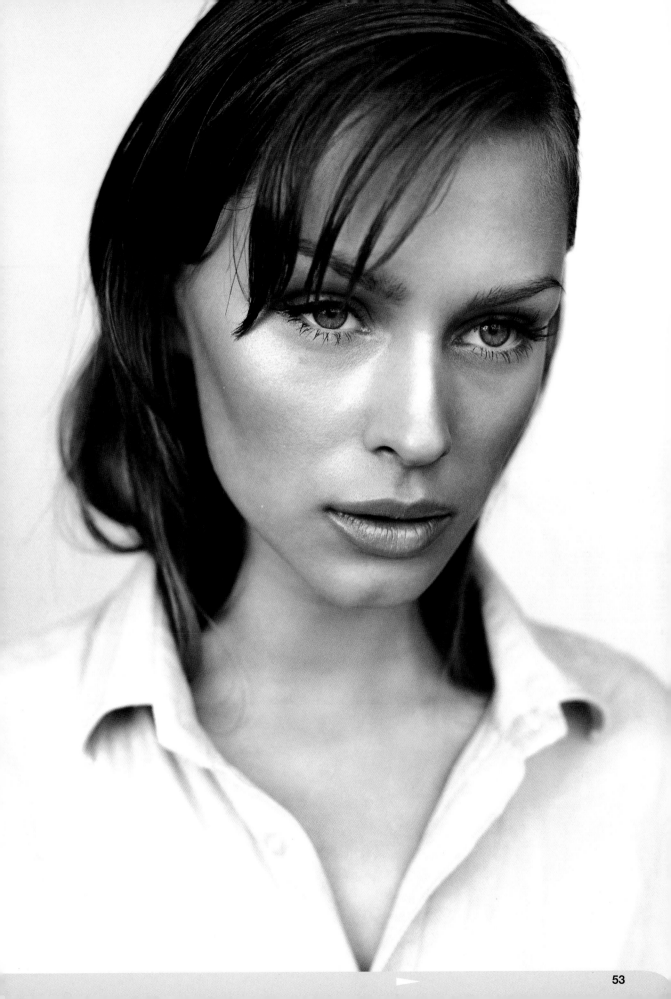

FASHION ACCESSORIES
03
and PROPS

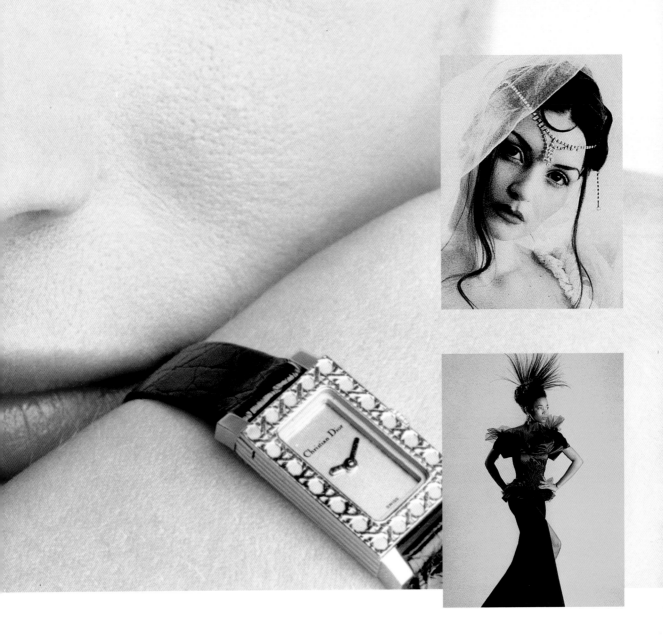

Sometimes the props or accessories may be the whole point of the image; one might say that the accessory (item of jewellery, for example) is the "hero" of the shot and that it is the model that is the "prop". In other cases, the props may be staging devices to add interest or motivation to a shot whose real focus is something else entirely; or else the accessory may be a point of detail that adds piquancy and punctuation to an over-all composition.

The power of the accessory detail should not be underestimated. Change the details and you change the emphasis, look and feel entirely. The inspirational element of props and accessories is important too. An imaginative, improvisational approach to a shoot can lead to interesting results as model and photographer explore poses and compositions that are led by the props on the set, inspiring experimentation.

WATCH ME

photographer **Jeff Manzetti**

client	Dior
use	Advertisement
model	Diane (Heidkrugger)
hair and	
make-up	Yannick Dys,
	Pascale Guichard
stylist	Laurence Heller
camera	Pentaz 6x7cm
lens	135mm
film	GPX 120/125
exposure	f/8
lighting	Electronic flash

This shot is constructed with two elements that must be considered. Because it is actually a fashion product shot of a watch, this is the key consideration.

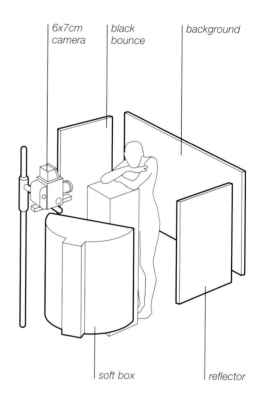

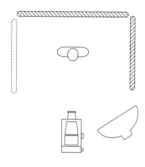

plan view

key points

The setting to a product shot is vitally important and can make or break the shot

Black panels are an effective way of introducing overall lowlights into a composition

As we see the watch is relatively small in shot but is perfectly lit, i.e.free from reflections and with the hands positioned to be clearly visible. A highlight placed on the shiny black strap separates the watch from the models wrist and provides just the right amount of separation to make the watch stand out.

The second element is the model, obviously just as important, but meaningless without the watch. The composition is contrived to show off the models beautiful face and is symbolic of the perfect face of the watch. The contrast is kept low to give a soft and romantic feel to the shot. A large soft box, high and to the right of the model is the only source, but is reflected from the right and behind by a white panel and the background respectively. A black panel to the left of the model increases the fall off to the left hand side of the shot.

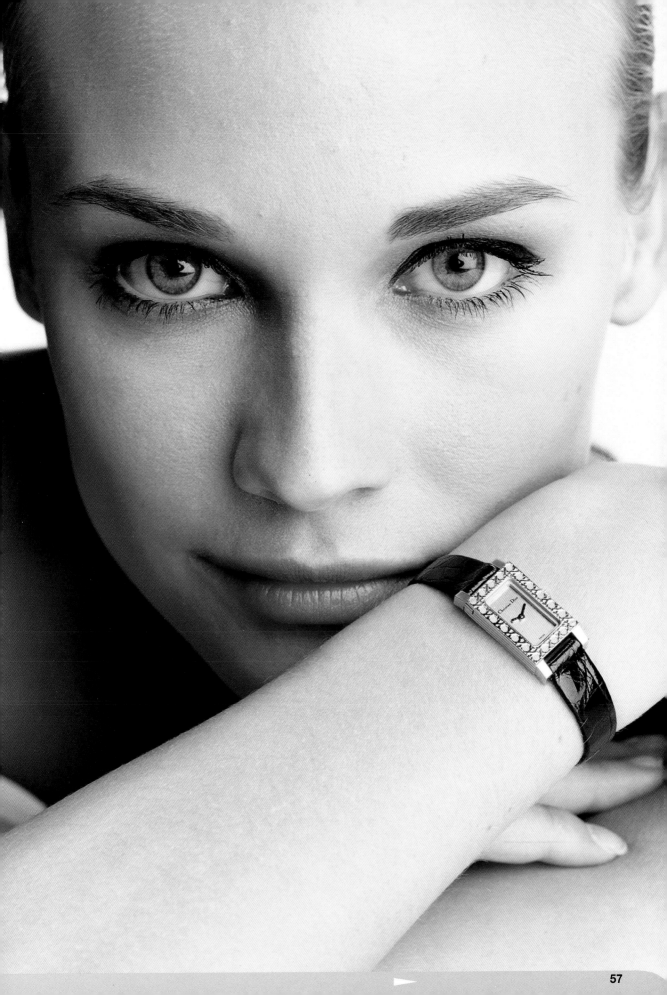

HILA

photographer **André Maier**

client	Mode-Info, Berlin
use	Editorial
model	Hila Marin for Next Models
art director	Jörg Bertram
make-up	Hélène Gand
stylist	Jörg Bertram
hair	Yoshi Nakahara for Oscar Blandi Salon
designer	Mark Montano
camera	35mm
lens	135mm
film	Kodak E100SW
exposure	1/15 second at f/11
lighting	Available light, fill-in flash
props and background	Rooftop at sunset

This shot was executed on a rooftop, with the New York skyline visible behind, serving as a backdrop. It is dusk and the colour of the sky ranges from rich mauve orange to deep blue.

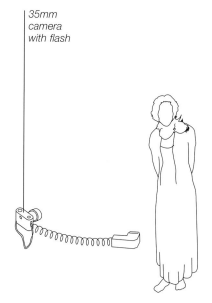

35mm camera with flash

plan view

key points

The introduction of a small amount of coloured light can really add to the impact of an image

Sometimes areas of both and sharp soft focus on the same main subject can enhance the shot

A hot-shoe flash is linked to the camera via an extending cable, which allows for greater flexibility in positioning what is basically an on-camera flash, off the camera. The flash is hand-held to the right of camera and gives even illumination on the face and good catch lights in the eyes. The use of a straw filter on the flash adds warmth to the face.

This is a long exposure for a hand-held shot at 1/15 second. The flash is fired only at the end of the exposure (rear curtain flash) to ensure the frozen clarity of the final image, so that only the periphery of the subject melts away into a haze as a result of the small amount of movement during the first part of the exposure.

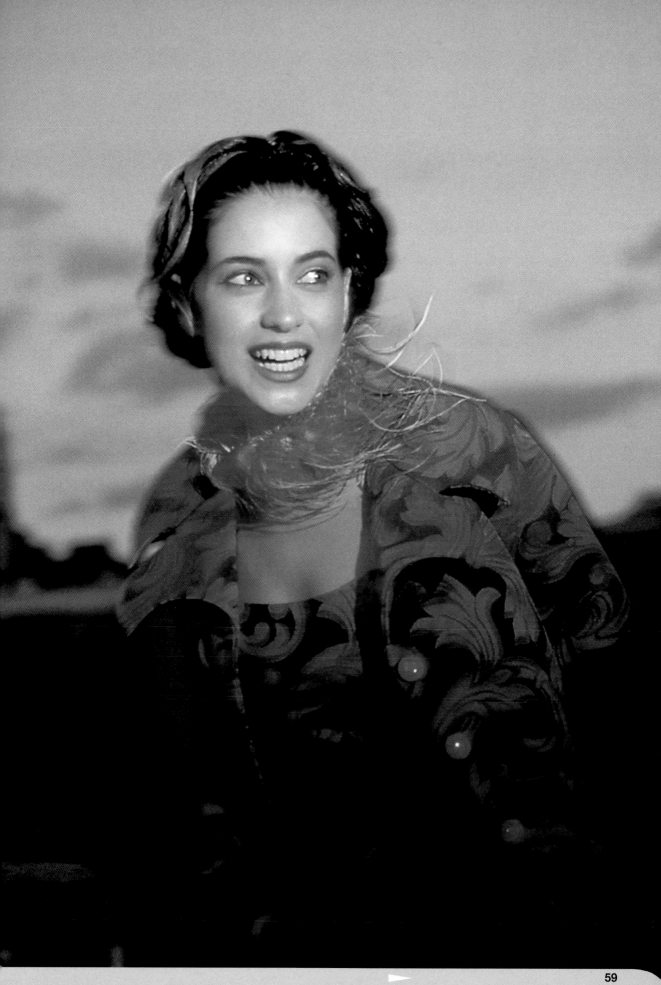

GIRL ON BOX

photographer **Wolfgang Freithof**

client	Mardome Collection
use	Promotion
model	Jewel Turner
art director	Jimmell Mardome
make-up	Nikki Wang
camera	35mm
lens	105mm
film	Fuji RDP
exposure	1/60 second at f/5.6
lighting	Electronic flash
props and	
background	Yellow paper
	backdrop, box

It is a common accusation that a picture of a fashion model must have been distorted for her to look quite so tall, thin and elegant.

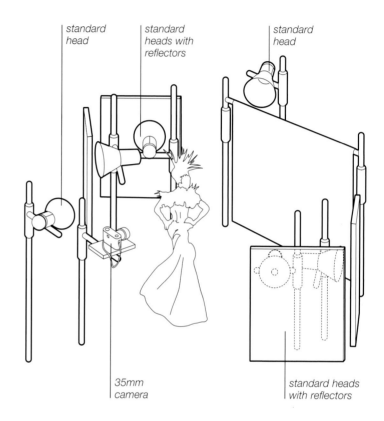

standard head *standard heads with reflectors* *standard head*

35mm camera *standard heads with reflectors*

plan view

key points

Polyboard wedges can be multi-purpose, throwing light forwards and backwards and also flagging the camera from lens flare

Light shot through a translucent silk umbrella has a different quality from light reflected off a non-translucent silk brolly

"They do it with mirrors" or "They do it with lenses," say the sceptics. Well, "They do it with boxes," as the title gives away, would uncover the trick in this particular case. The model, tall thin and elegant as she is, is standing on a pedestal for extra height in order to show off the long designer dress in all its splendour; the effect on the proportions in the final shot is superb.

The hair design is tall, too, and is lit specifically by a dedicated spot from behind. The main light from the front is high up and behind the camera and shoots through a silk umbrella. Two standard heads shooting into a wedge of white reflectors are used on both sides to give diffused fill to the sides and to light the background.

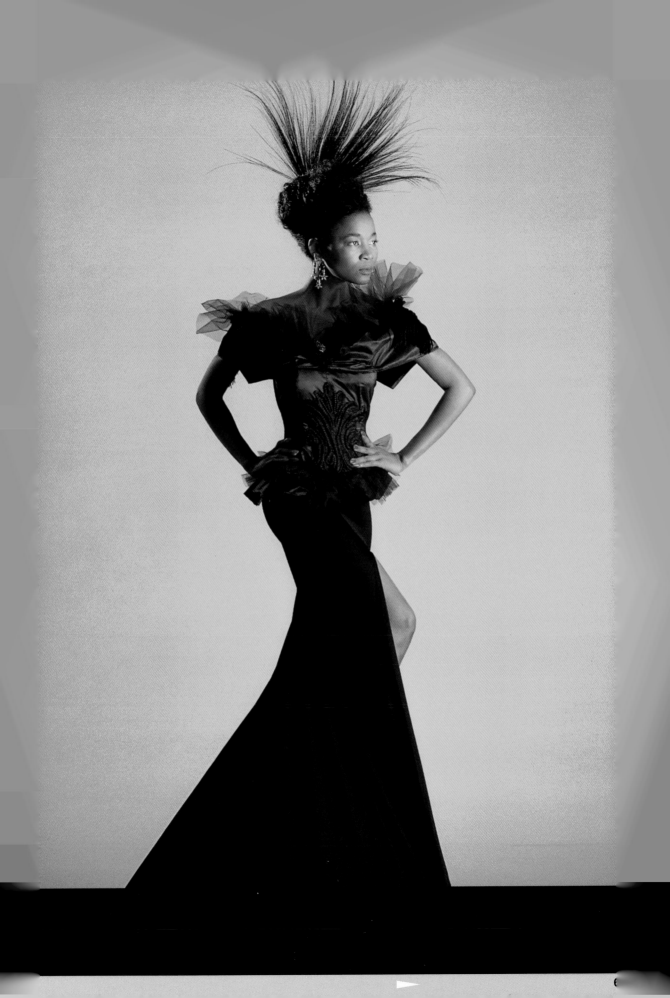

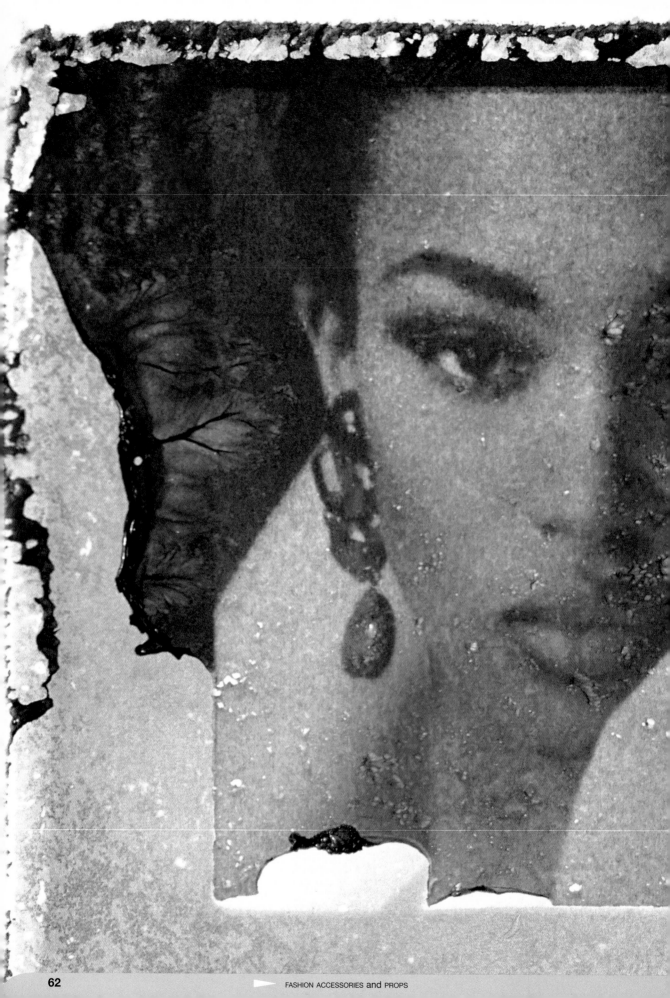

▶ FASHION ACCESSORIES and PROPS

NAOMI

photographer **Wolfgang Freithof**

client	Fernando Sanchez
use	Editorial
model	Naomi Campbell
art director	Quintin Yearby
make-up	Sam Fine
hair	Ron Capozzoli
camera	6x6cm
lens	150mm
film	Polaroid 669
exposure	1/60 second at f/8
lighting	Electronic flash

An assignment to shoot Naomi Campbell must be every fashion photographer's dream commission.

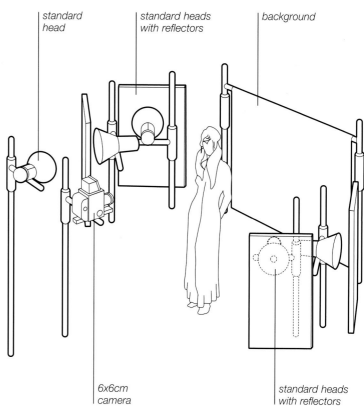

plan view

key points

Dark skins absorb a lot of light; plenty of illumination is needed

It is essential to make dupes of Polaroid transfers as a method of preservation

The immaculate and exquisite features, shown to stunning effect here by Wolfgang Freithof, make it easy to see why she is a "supermodel". The model is standing in the pool of soft light that the pairs of standard heads shooting into wedges on each side provide. Some more soft light is provided by the main key light in the form of a standard head shooting through a silk translucent umbrella, placed above and behind the camera. This keys the featured side of the face and provides the modelling to define its shape.

Notice the tightness of the composition and framing; the face is framed by the clothing, which also provides a clear backdrop for the earring.

photographer's comment

Polaroid processed for 10 seconds and then transferred onto a textured drawing paper using a glass plate and rollers

GIRL WITH CAT

photographer **Gordon Trice**

client	Agfa
use	Convention display
camera	Fuji 680 (6x8cm)
lens	100mm
film	Agfapan 100
exposure	Not recorded
lighting	Electronic flash

Good rapport between model and animal is essential for this kind of shot to succeed. The bond (or lack of it) will be immediately apparent in a final shot.

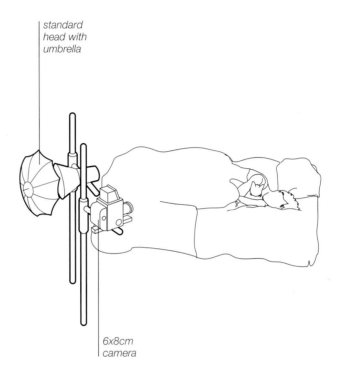

standard
head with
umbrella

6x8cm
camera

plan view

key points

Using reflective light eliminates "red-eye" which in animals usually appears as a blue colour

Make sure that any extraneous factors such as model phobias or allergies to cats have been investigated well before the shoot!

When working with animals it is always as well to be prepared to shoot plenty of film and to spend plenty of time to get just the moment that you want.

In this superb shot Gordon Trice has captured the direct gaze of the cat in the perfect face-on position for an appealing and natural-looking moment. The shot was lit with a single standard head set at 1200 watts, shooting into a large soft white 52-inch umbrella positioned some 10 feet from the subject, to the left and just above the camera.

This gives the good catchlights in the eyes and pleasant gradation of light and shade across the model's arm, throat and face and highlights on the glossy hair.

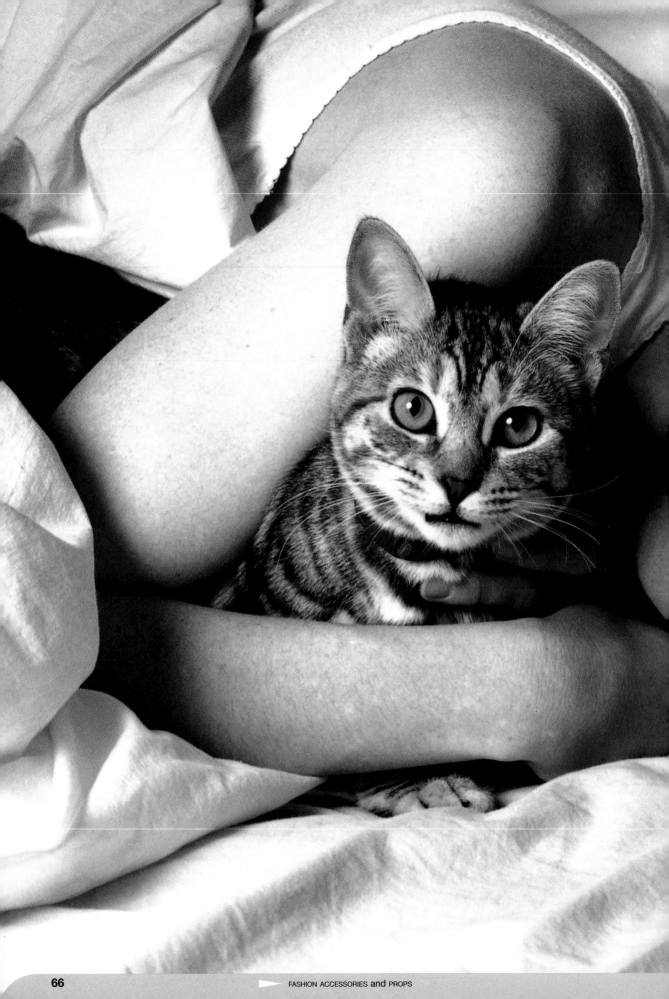

FASHION ACCESSORIES and PROPS

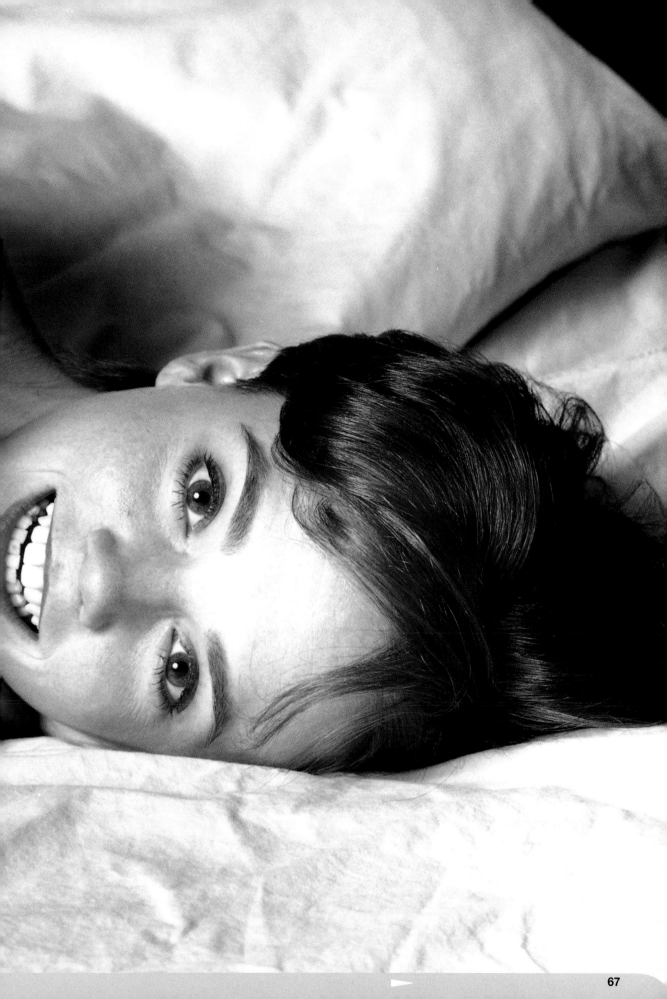

CARTWHEEL

photographer **Bob Shell**

use	Stock
model	Heidi
camera	Mamiya 645
lens	110mm
film	Kodak E 100S
exposure	1/60 second at f/16
lighting	Available light, fill-in flash
props and	
background	Cartwheel, foliage

This is well-executed shot using the surrounding elements to influence the lighting achieved.

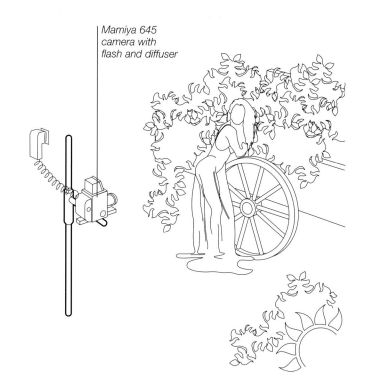

Mamiya 645
camera with
flash and diffuser

plan view

key points

Choose a location carefully – interest can be added to the light by nearby things such as trees, foliage, water, and other natural features

Beware a greenish pallour if the light is strong and the chlorophyll is plentiful and nearby!

The sun is diffused by the foliage of the trees at the location, giving slightly dappled light. The highlight areas, though are evident on the camera left side of the model, along her back and side of the face. These areas are lit by the portable flash with diffuser to camera left. So in effect, this flash outstrips the sum by sheer proximity, to become the key light while the sun is relegated to provide fill-in light modified by the natural gobo of the nearby foliage.

The prop is a central element in this shot: the cartwheel provides visual interest, is a rest for the model to lean on, both inspiring and supporting her pose, and also helps to define the context and location of the shot in a semi-narrative way.

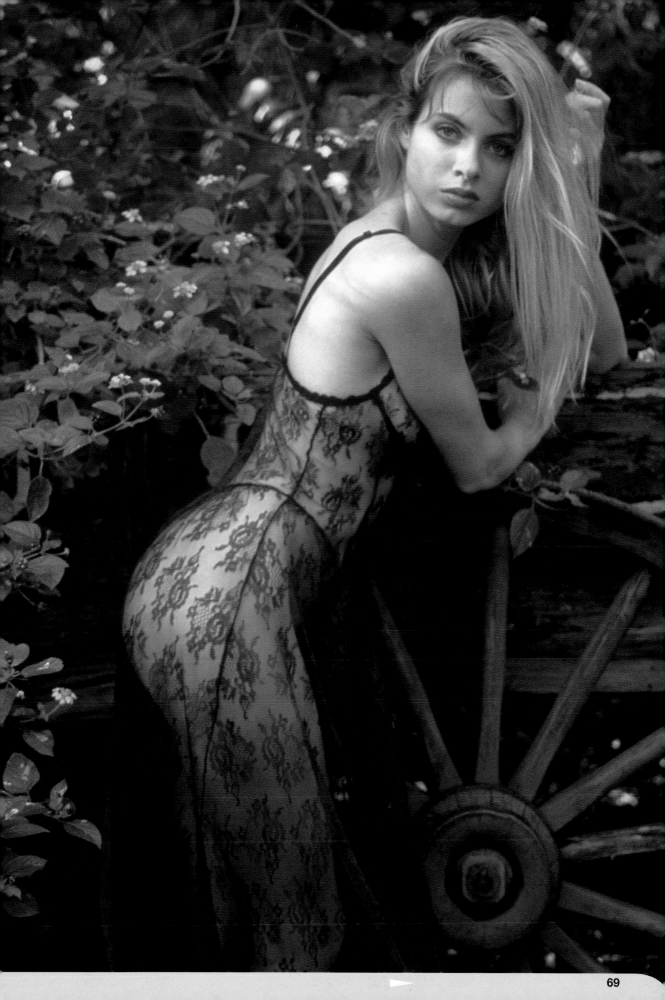

WEDDING HEAD

photographer **Renata Ratajczyk**

Use	Personal work
Model	Joa
Camera	35mm
Lens	135mm
Film	Fuji Provia 100
Exposure	1/60 second at f/11
Lighting	Electronic flash
Props and	
background	White background

The model's large, dark velvety eyes, emphasised by make-up, her carefully dressed dark hair and exquisitely painted lips, have a very dramatic impact amongst the froth of wedding white lace and net.

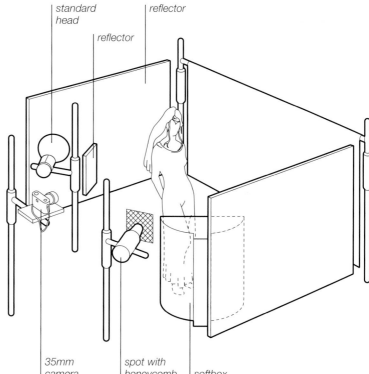

standard head
reflector
reflector
35mm camera
spot with honeycomb
softbox

plan view

key points

Never under-estimate the importance of the make-up artists and stylists – no amount of soft lighting or petroleum jelly will give a romantic final image if the styling (make-up, hair, expression, pose) of the subject is not right in the first place

A small reflector can be just as important as a very large soft box

The face and throat of the model seem to float in a sea of the white of the dress. The face area and the bulk of the dress are lit separately. To the far right there is a medium soft box on the whole of the model. Also to the right but not so far round there is a standard head with a snoot, honeycomb and diffuser keying the right side of the face. To the left of the camera a standard head with barn doors bounces off the large white reflector panel to the left of the model,

lighting the volume of the dress on that side, and giving an over-all lower level of light than on the face area. Diagonally opposite the soft box, behind the model, there is a standard head with honeycomb and barn doors to light the veil from the rear.

Finally, There is a small reflector to the left of the model to lighten the shadows on the left side of the model's face.

photographer's comment

Strobes were used. I wanted to create soft romantic light with some dramatic highlights.

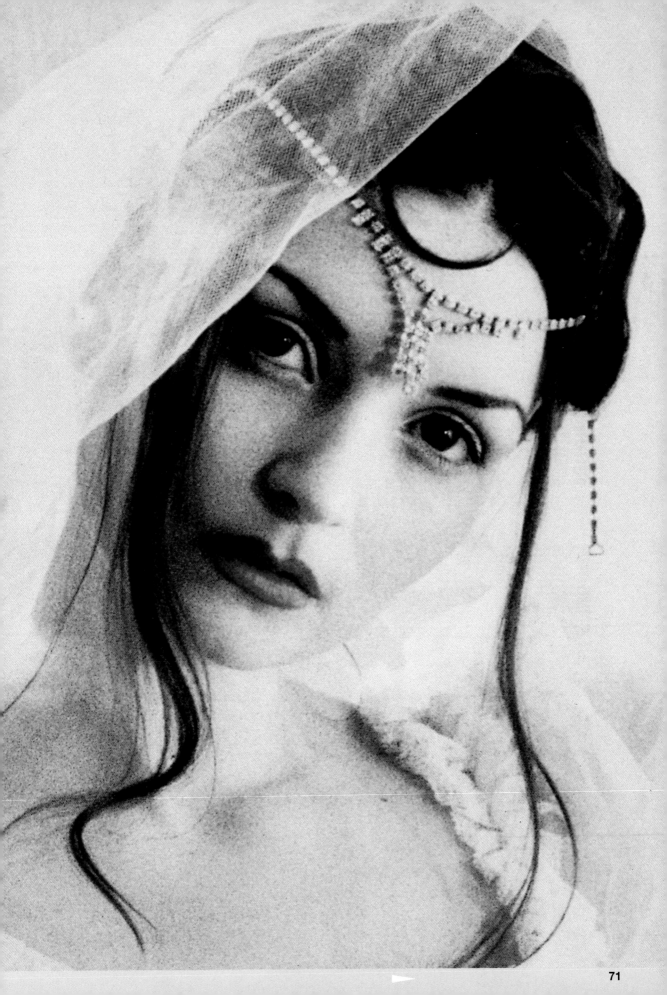

MODELLING
CLOTHES
04

For the wheels of the fashion industry to turn, the products must be constantly promoted and on view, informing and enticing potential customers to buy into whatever is in vogue (or, indeed, in *Vogue* - not to mention *Elle*, *Tatler*, and the host of other fashion glossies!). In a sense, all the photographs in this book are about "modelling clothes", but in this particular selection of shots the more direct, in-your-face approach used to really show off the fashion products is the undeniable emphasis.

Here the models are always clearly depicted so that the clothes are displayed to best advantage, whereas elsewhere in this book, a less tangible "feel" or "mood" or aspect of lifestyle might be what the camera needs to capture. But the shots in this chapter look at the whole business of showing off clothing – from the photojournalistic technique employed in the context of a catwalk show, as in André Maier's "New York Fashion", to the studio approach of Chris Rout's "Jessica Atomic".

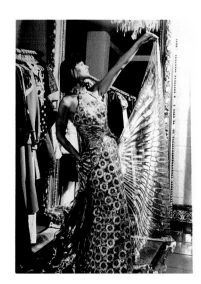

JESSICA ATOMIC

photographer **Chris Rout**

client	Atomic
use	Promotion
model	Jessica
stylist	Karen Starr
camera	35mm
lens	70–200mm
film	Kodak E100S
exposure	Not recorded
background	Blue Colorama backdrop

The emphasis in this shot is firmly on the dazzling white outfit, which stands out to good effect against the rich blue Colorama background.

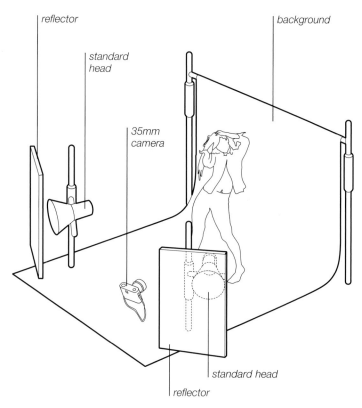

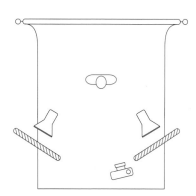

plan view

key points

Black panels can be used to increase light fall-off

Light usually expresses purity in the imagery of fine art

To maximise the impact of the gleaming costume, Chris Rout has created a bright pool of light around the model by shooting two standard heads into white polyboard reflectors, on either side. This gives the brightest highlight areas on the sides of the model; what might be described as a marginally frontal rim light, in fact.

The front of the model is lit less directly than are the sides, and is consequently in more of a fall-off position. This allows some of the texture of the fabric and detailed styling on the clothing to register more clearly, since the glare from the white is less intense at this point.

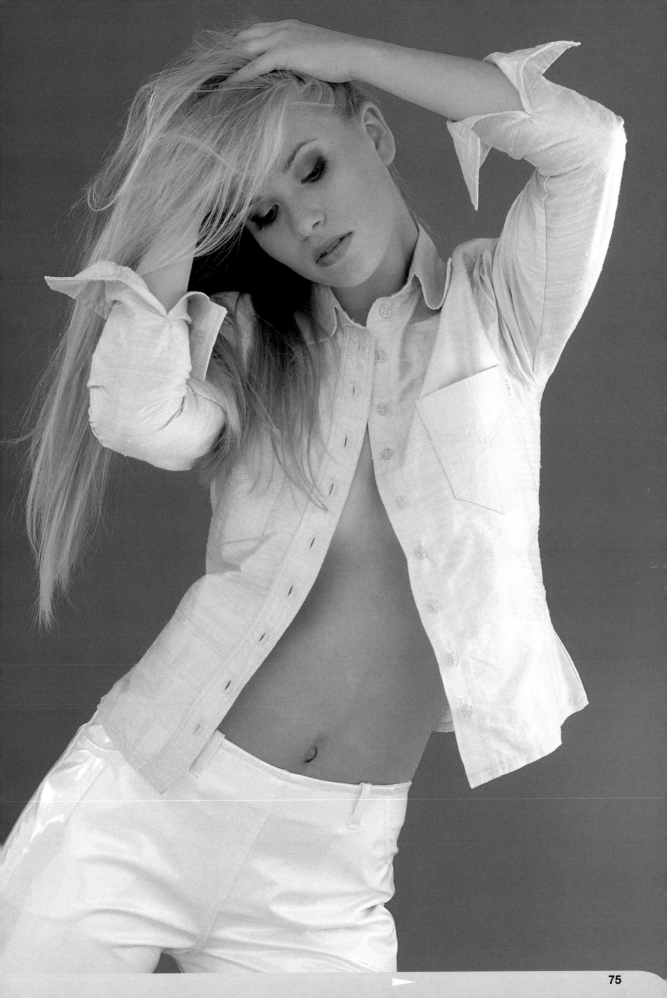

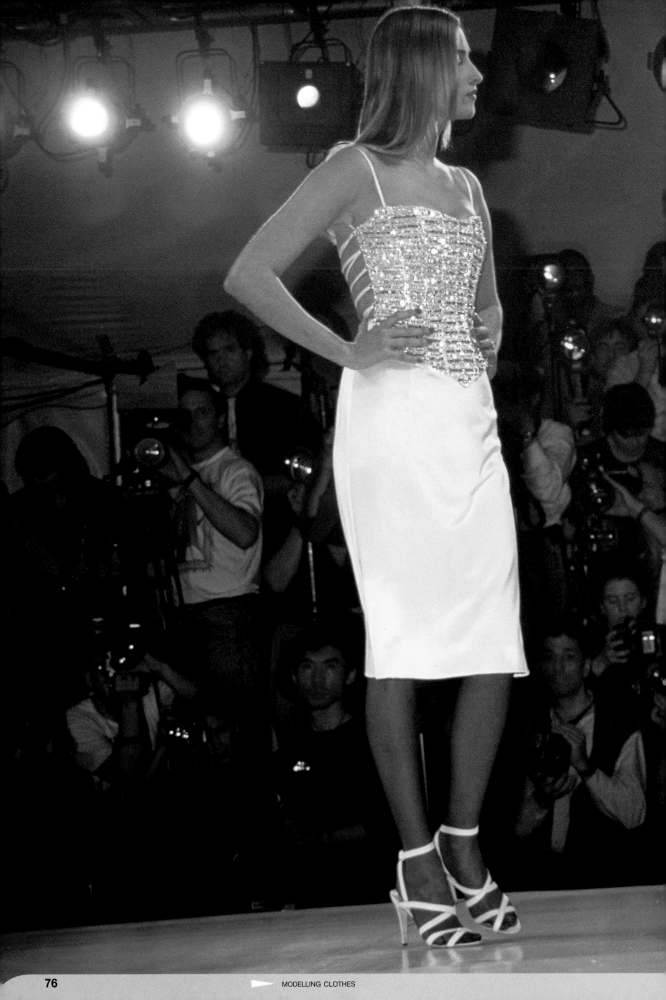

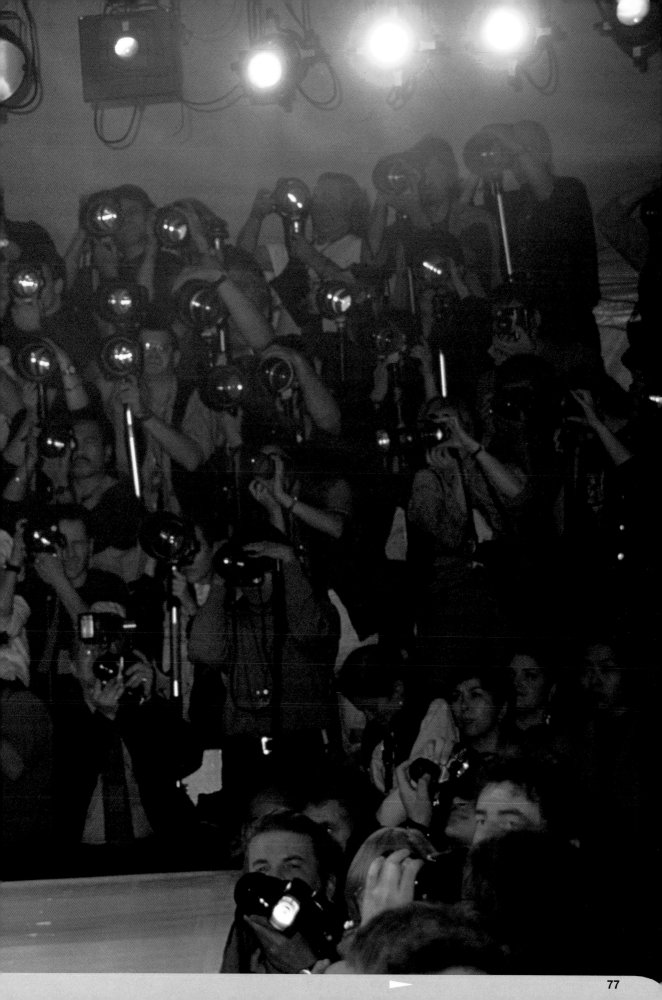

NEW YORK FASHION SHOW

photographer **André Maier**

use	Portfolio exhibition
camera	35mm
lens	50mm
film	Fuji Velvia
exposure	Not recorded
lighting	Available light, fill-in flash
props and	
background	Live catwalk show

This is a situation where the photographer had to work with the lighting that was already in place. For a catwalk fashion show a multiplicity of stage lights surround the runway, and are visible in the shot.

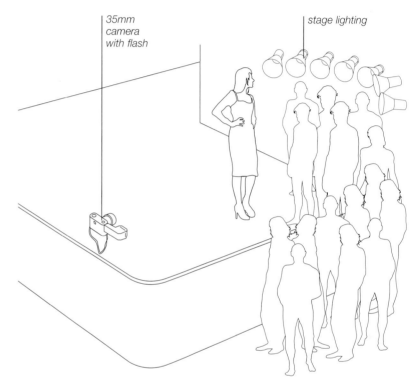

plan view

key points

In a situation like this it is worth considering utilising flare as a creative aid to composition

It is always a challenge to find an unusual 'take' on a commonly photographed subject.

Spot metering is an invaluable aid for catwalk photography

These banks of tungsten lights give the deep golden warm glow to the picture. Only the model's dress and shoes show up as a bright clear white, because of the on-camera electronic flash used by André Maier for fill-in, which outshines the tungsten ambient light.

It is of course more common at a fashion show for a photographer to concentrate on the model and the clothing that is being displayed, but this shot is more of a documentary-style image than a traditional catwalk shot. André Maier wanted to illustrate the extended wall of photographers with an array of vastly expensive cameras and lenses surrounding the stage.

photographer's comment

I wanted to catch what was happening in a general sense, more than just on the catwalk.

LISA

photographer **Jörgen Ahlström**

client	LC
use	Editorial
model	Lisa
camera	6x7cm
lens	75mm
film	Kodak TriX 400
exposure	Not recorded
lighting	Available light

The photographer was 15m above this stunning paved square, shooting from the balcony of a nearby building.

plan view

key points

Some locations offer a background that simply cannot be emulated – there is no substitute for the right thing, the real thing, in these cases

It may be necessary to get police permission and co-operation in order to ensure a clear view of a large expanse of public space

Only available light was used, which in this case was bright sun on the far side of the model. The location and angle of view are what make this shot so visually exciting. The geometric patterns of the cobblestones form an expansive mosaic background, and there is a gradient from light to dark from the top to the bottom of the picture because of the angle of sunlight and plane of the surface in relation to the photographer's position. The position of the sun gives fairly even light on the surfaces of the cobbles while allowing the recessed mortar areas between to stay deep black.

The upper surfaces of the model just catch the light directly, and the paved surface acts as a reflector to provide fill on the rest of the body.

MODELLING CLOTHES

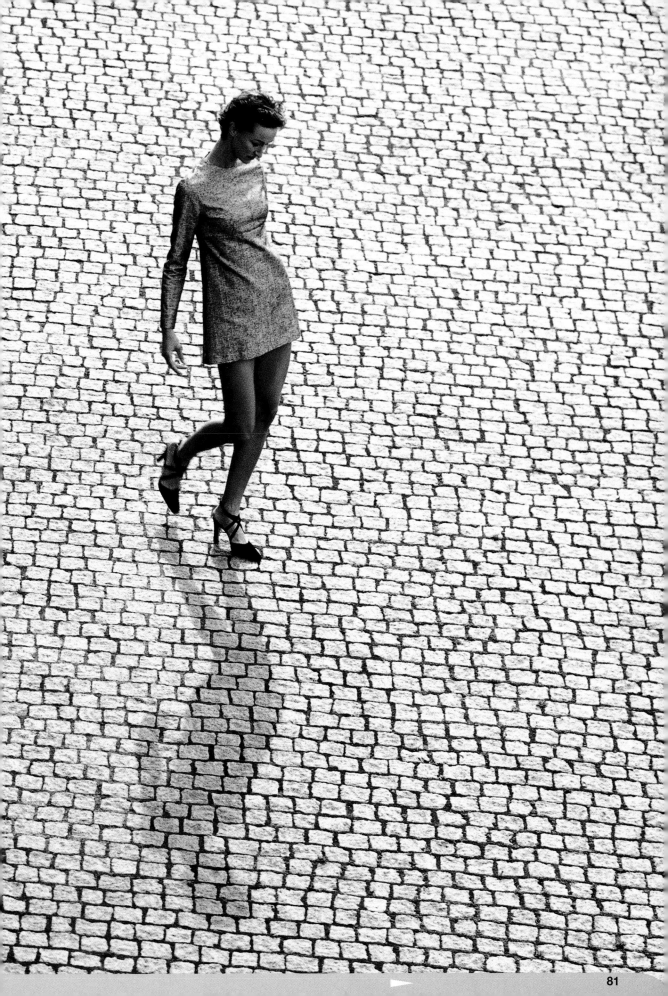

ATELIÈRE

photographer **Ben Lagunas and Alex Kuri**

client	Claudio Designer
use	Editorial
assistant	Isak, Christian, Paulina, Janice
art director	Ben Lagunas
stylist	Leonardo
camera	6x6cm
lens	210mm
film	Kodak Tmax CN
exposure	1/250 second at f/11
lighting	Tungsten

The camera is straight-on to the model, with a standard head to camera right.

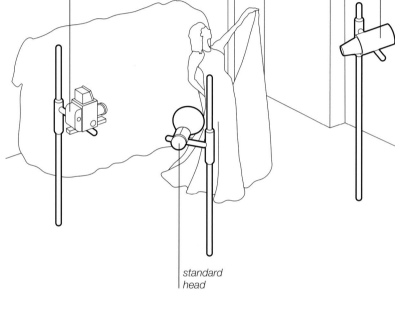

plan view

key points

When lighting for theatrical effect, traditional rules, such as the back light being opposite the key light, need not apply

Prop lights can double up as sources

Three-quarters behind the model is a focusing spot directed at her, which gives a back light that shines through the length of gauzy dress fabric she is holding up and adds rim light to the edge of her arm.

The only other source is the crystal chandelier that is visible at the top of the image, basking in a bright pool of its own light. Everything about this shot shines. The fantastic costume, the stylish fashion workshop setting, the beautiful and immaculately made-up model, the theatrical pose and the sparkling quality of light all combine to condense the glamorous appeal of the world of fashion into a single stunning image. The effect is reminiscent of the work of Cecil Beaton combined with the surrealist work of Angus McBean.

photographer's comment

Using toners with this kind of film produced warm 'colours'.

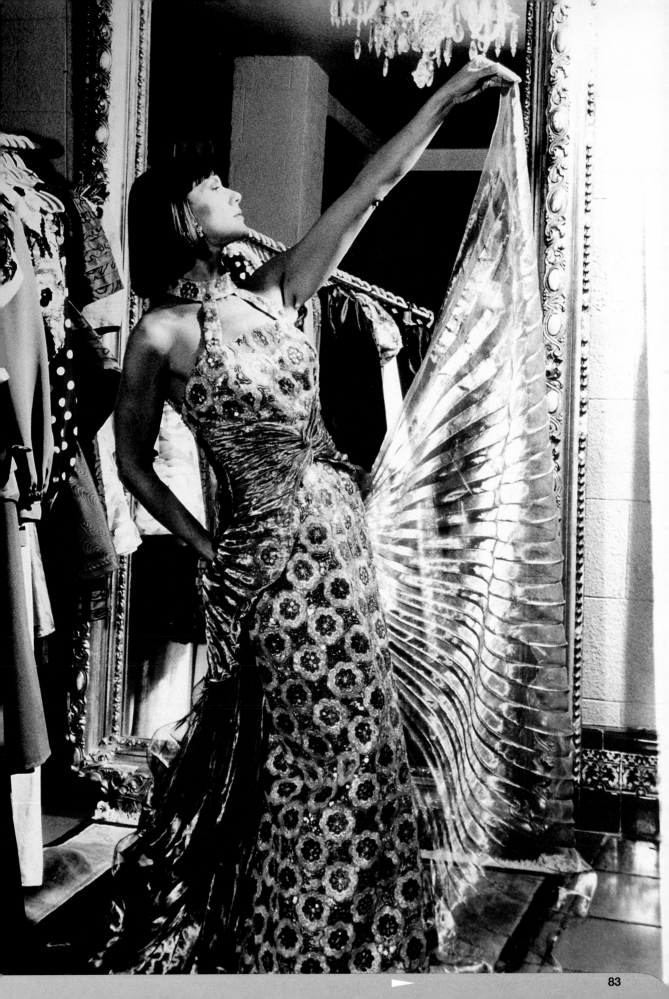

FEARFUL GLANCE

photographer **Kazuo Sakai**

client	Personal work
camera	35mm
lens	85mm
film	Kodak E100SW
exposure	1/125 second at f/5.6
lighting	Electronic flash

This striking and somewhat disturbing image was created in several stages by Kazuo Sakai. The image of the woman was shot in a studio with a basic lighting set-up.

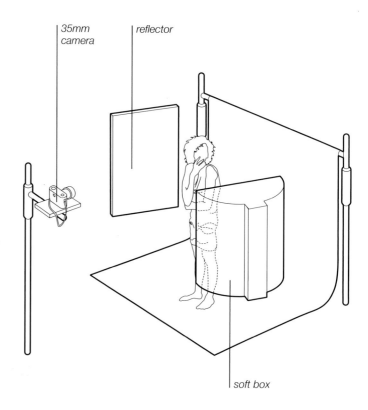

plan view

key points

Plan out an image carefully when electronic manipulation is to be introduced

Continuity of contrast is important when different elements are being used to construct a shot

A large full length soft box to the right of the camera and a white reflector slightly to the left of camera. The model is actually standing against a plain off white textured canvas background. This canvas will allow the photographer to place a more appropriate backdrop onto this canvas, using a computer paint package.

The model is directed by the photographer to look fearful and afraid, hence the body language and self embracing pose. The lighting also reflects this being somewhat stark and contrasty.

Adobe Photoshop on the Macintosh is used to add a chaotic background to achieve the end result that the photographer had in mind.

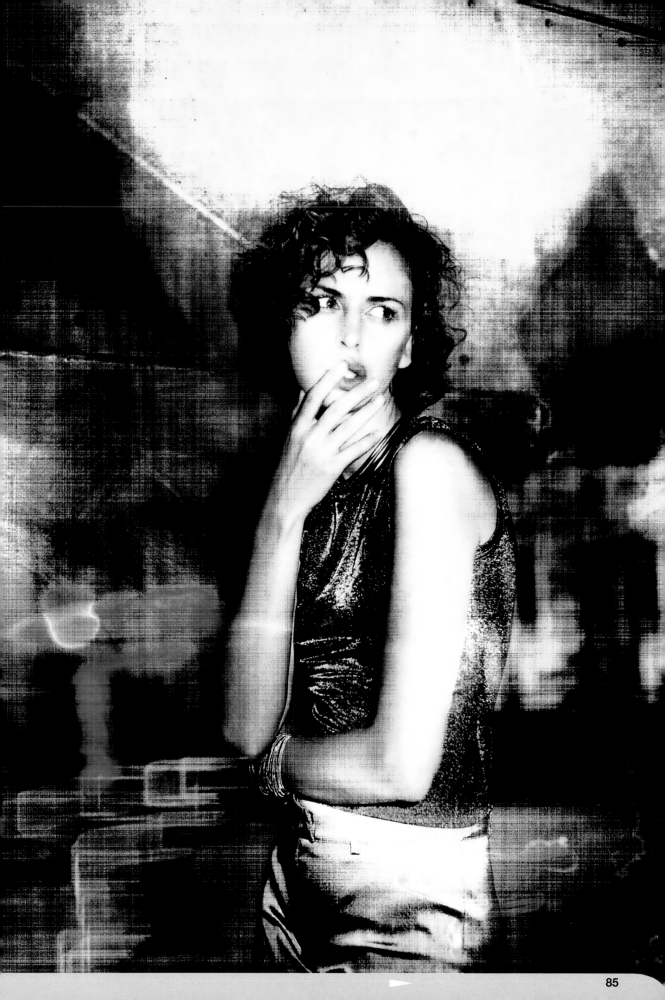

SUIT

photographer **Simon Clemenger**

use	Model portfolio
stylist	Steven Young
designer	Steven Young
camera	35mm
lens	28mm–80mm at 35mm
film	Ilford XP2
exposure	Not recorded
lighting	Available light

"Mad dogs and Englishmen" – or, in this case, a model and a photographer – "go out in the midday sun"...

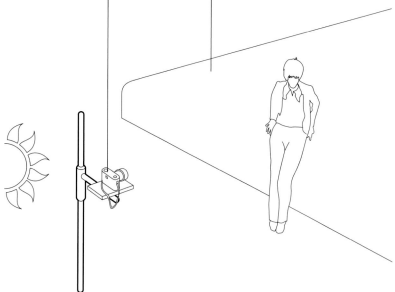

plan view

key points

This graphic high-key effect is the result of bright midday sunlight and carefully considered printing

A simple unobtrusive background is often preferable when showing off a full-length outfit

The extreme shortness of the shadows indicate the approximate time of the shoot as noon, while the position of the shadows show that the model is almost directly face-on into the bright sunshine.

This gives good detail in both the white shirt and the dark fabric of the suit. The dark sunglasses not only complete the 'look' and complement the fashion styling of the shot, but are also

an absolute necessity for a model who is required to look straight ahead into strong sunlight.

Even in black-and-white, the viewer can almost feel the heat and power of the dazzling sun reflecting off the page. The model's pose – as if pinned to the wall by the sheer force of the sunlight – is an excellent choice to convey and emphasise this feeling.

photographer's comment

This is very interesting film. This shoot was the first time that I ever used it.

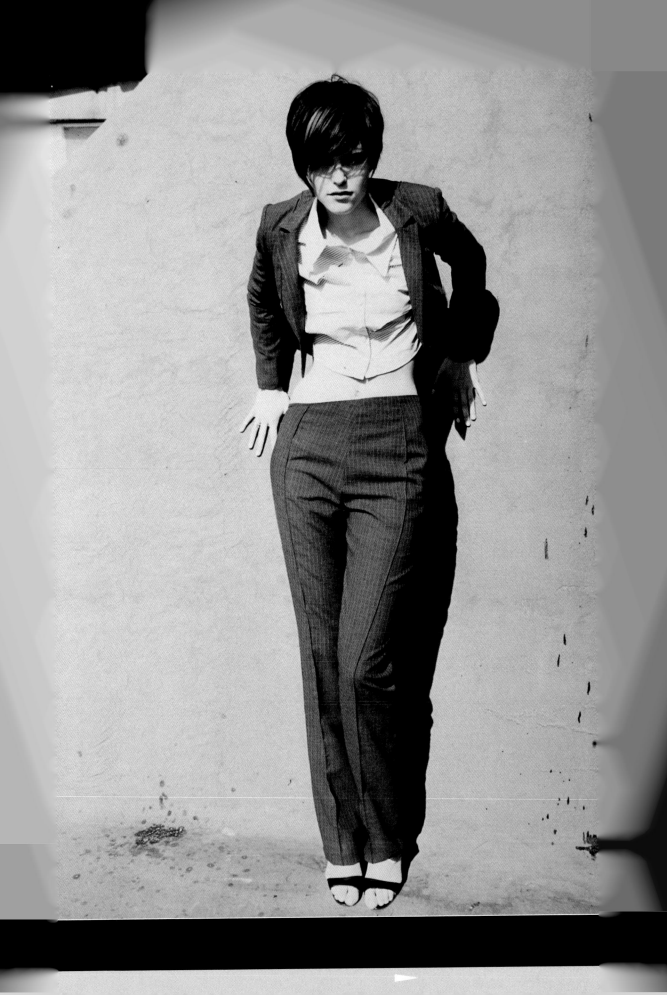

GIRL ON ROOFTOP

photographer **Wolfgang Freithof**

client	BFIA
use	Editorial
art director	Irasema Rivera
hair and	
make-up	Kevin Sharpiro
camera	35mm
lens	85mm
film	Ilford XP2
exposure	1/60 second at f/4
lighting	Available light,
	electronic flash

Wolfgang Freithof has positioned the bare bulb flash head in the same direction, in relation to the model, as the sun at the time of this shot.

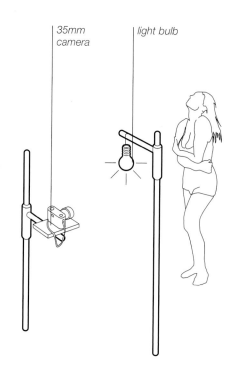

plan view

key points

Constant exposures combined with an initial clip test is important to determine correct development time when cross-processing

Different hues, blueish, greenish or brownish, can be achieved with XP2 by different combinations of rating and development time

It combines with and complements the ambient light available and emphasises its directionality to give strong highlights along the model's back and side nearest the camera. Her front is in the fall-off shade area away from both the sun and the flash.

The blue-green hue of the shot is an appropriate look for a spotlessly white lingerie shot of this kind. The cool, crisp, clean look is ideal to convey just such qualities about the garments being modelled. The choice of fair-skinned blonde model, in combination with the film stock and processing method used, keeps the emphasis on lightness and brightness.

photographer's comment

The film was rated at 50 ISO and processed E6, pushed two stops to get the washed-out skin tones.

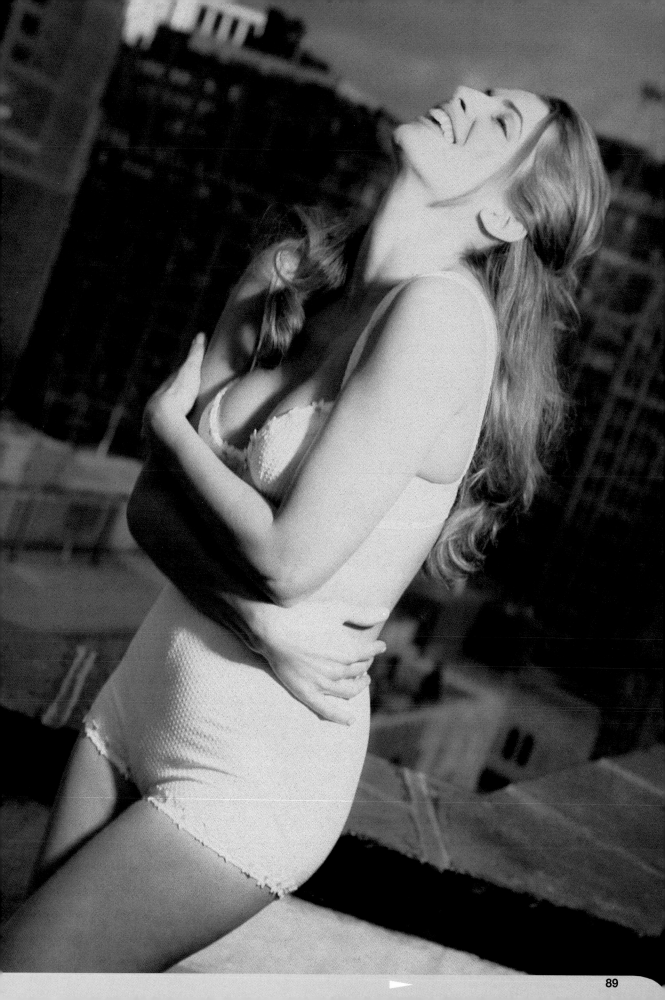

BRIDE

photographer **Gordon Trice**

client	Martha Stewart Living
use	Bridal issue submission
camera	8x10 inch
lens	210mm
film	Fuji RDPII
exposure	1/30 second at f/22
lighting	Electronic flash
location	The French Room at the Adolphus Hotel, Dallas

"I used material that I refer to as 'socks'," says Gordon Trice. "The material is used to soften the effect or to fine-tune the exposure in selected areas.

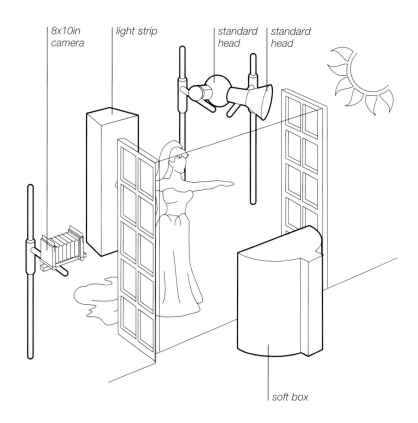

8x10in camera · light strip · standard head · standard head · soft box

plan view

key points

Be extremely careful when working with reflective surfaces that no stands, heads or crew are reflected

Be aware that white clothing can fool an exposure metre so take a range of readings from the material and light the rest of the scene appropriately

These 'socks' can be made of any translucent material. I have a variety of tints of fabrics from a warm cream to white white. I use them to warm or cool particular areas of the shooting arena as needed."

The large super-pro soft box was positioned just outside the French doors of the restaurant on the balcony. The medium super-pro strip soft box was set high and slanted downwards to illuminate the back of the dress and to create rim light for the bride's head.

One of the standard heads fitted with a large honeycomb grid was placed about 10-15 inches from the floor, pointing upwards to the ceiling through the tree to create a pattern on the ceiling from the leaves. Another standard head was placed five feet from the ground with a 10-inch standard reflector to create detail in the shadows of the highest point of the room. A final standard head was placed at the rear of the set about 10 feet from the floor and was a bare bulb tube.

photographer's comment

Learn to use all the light you have.

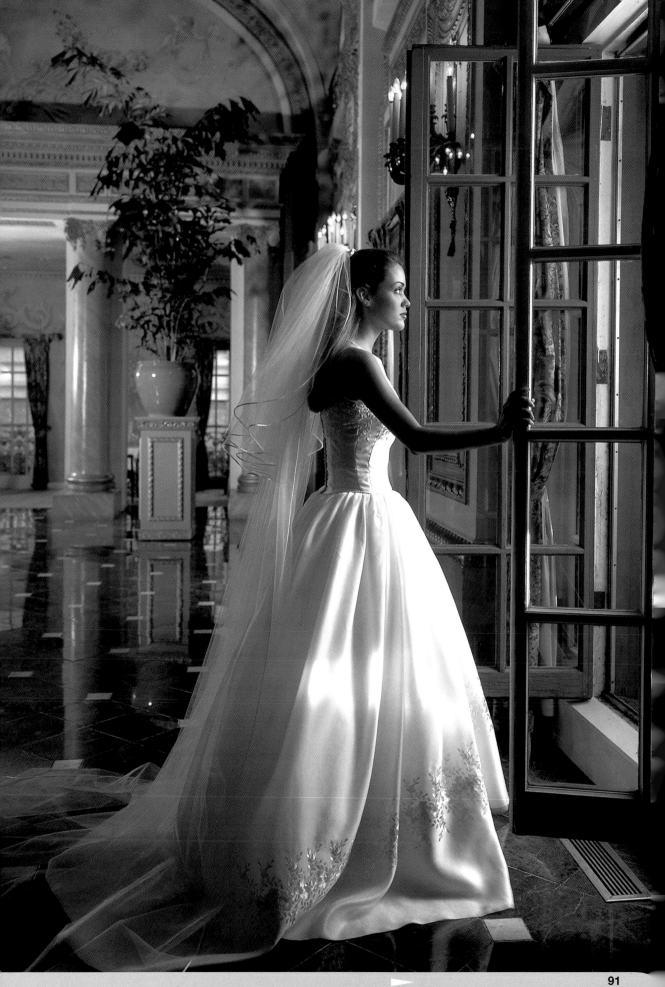

RENÉE

photographer **Jörgen Ahlström**

client	Tatler
use	editorial
model	Renée
camera	6x7cm
lens	35mm
film	Kodak GPH
exposure	not recorded
lighting	available light, daylight
	fluorescent tube
props and	
background	white blinds

Daylight is coming in through window blinds directly ahead of the model and is diffused by a fine background that nevertheless allows the pattern of the blinds to register.

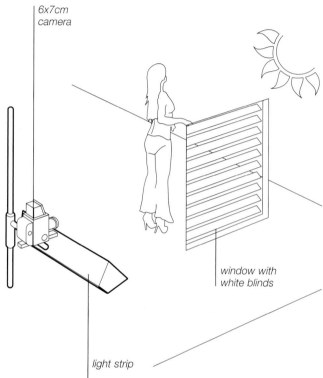

6x7cm camera

window with white blinds

light strip

plan view

key points

When daylight falls into shadow, for instance under the shoe, the colour temperature dramatically increases, which is why there is a blue tint in the shadowy areas on the sole

Colour negative stock is far more suited to high-contrast imagery like this. Transparency stock probably could not hold such a contrast ratio

A second window to the right, again modified by blinds, is to camera right and introduces side light on the shoes. A fluorescent daylight tube is horizontal to the ground not far off the floor, between the camera and the model. This lifts the shadow detail of the floor and

careful directing of the model ensures that the left silvery shoe stiletto picks up a bright highlight from this source, while the right stiletto is tilted so as to avoid it. A further reflection of the tube is clearly visible in the black supporting part of the right shoe heel, however.

BLACK SHORTS

photographer **Craig Scoffone**

client	Fanky Enderman Clothes
use	Editorial
model	Candice
camera	35mm
lens	75-125mm zoom
film	Agfa APX
exposure	Not recorded
lighting	Available light
props and	
background	An old loading dock off an old crumbling warehouse

Craig Scoffone believes in making good use of the available environment when shooting on location.

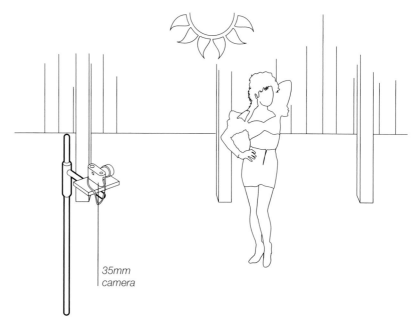

35mm
camera

plan view

key points

Carpe Diem: when working with available light, conditions can change very quickly depending on time of day, cloud movement and so on, and it is important to seize the moment

Constant metering is essential with changing light conditions. It is always worth having several reflectors to hand

Just as in "Alicia" he used skyscrapers for reflectors and in "Shadow" he capitalised on the brief moments of low twilight sun, here he uses the unlikely lighting props of light coloured cement as a bounce, in combination with the light already diffused by passing clouds.

"The day of this shoot there were scattered clouds late in the afternoon," he says. "When this shot was taken, the sunlight was semi-diffuse with cloud cover. The light coloured cement in the foreground provided great reflected light from below. No additional reflectors were needed or used."

This is an example of seeing the possibilities of the moment and exploiting them. The diffuse available light and reflected light on the front of the model give an even look, while the costume and position of the model in relation to the light ensure some degree of fall-off to the sides, adding that distinctive black edge definition to the legs.

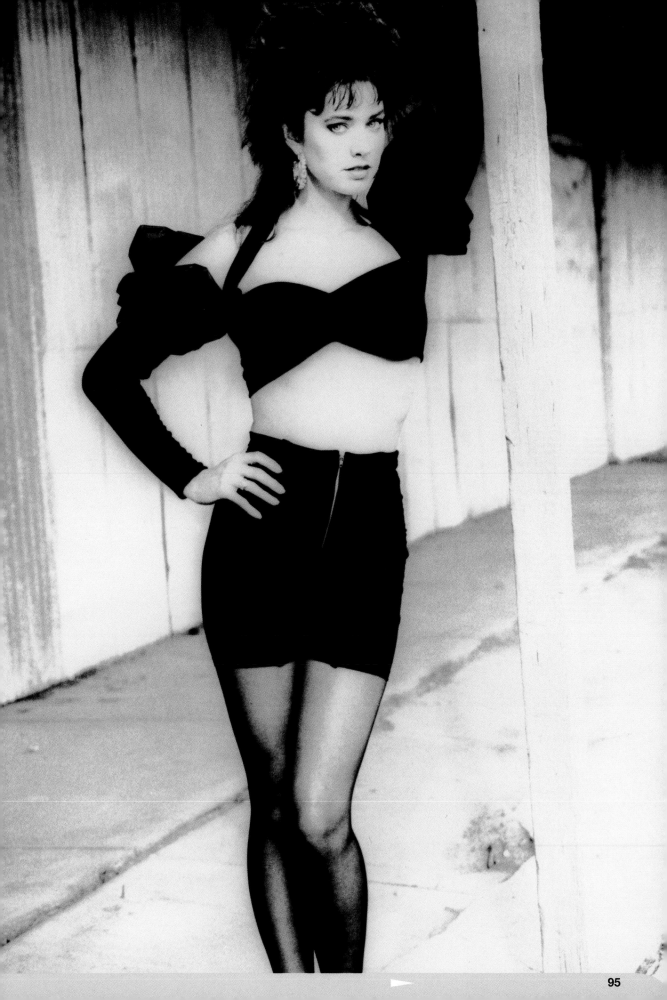

HAIR and MAKE-UP

05

The single most dramatic thing a person can do to bring about a bold change of image is to change the impact of their face. The importance of hair and make-up styling in defining an image or look is quite clear from the shots in this chapter. The style chosen need not be unconventional or outrageous to be effective (though of course these qualities can be powerful too); as with so many aspects of visual imagery (including photographic lighting) there are situations where less can be more. The clean simplicity of a look like Craig Scoffone's "Hair" shot could not be more removed from Jörgen Ahlström's high-impact "Linda" shot but both have their own impact. For the photographer, hair and make-up shots present particular challenges. How to convey the texture and colour of the hair? How to depict the make-up? Is it to be emphasised or underplayed and used as a tool that is then rendered invisible in the final shot? The permutations are endless.

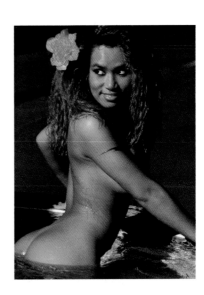

CALLIGRAPHY FACE

photographer **Marc Joye**

Not everyone would think of using Japanese calligraphy as a fashion make-up accessory, but Marc Joye uses this interesting visual element with subtlety and style.

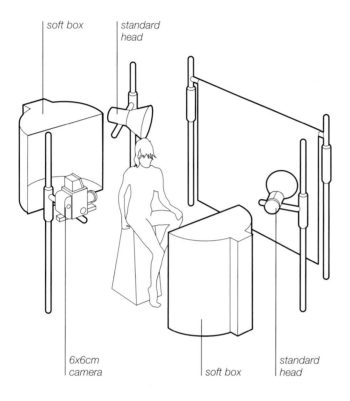

soft box

standard head

6x6cm camera

soft box

standard head

He has experimented with a variety of styles of body painting in his photography, and sometimes adds calligraphy or ink-design decoration to slides after the shoot. This shot shows his fascination with the idea in close-up. "By setting some more light on the background we created a *contre-jour* effect, bright light!" he says. "An aperture of f/11 was chosen as we liked a lot of unsharpness, with only the eye and calligraphy sharp."

Two soft boxes brightly and evenly illuminate the background. The model is quite close to the camera and is standing between two one-metre square soft boxes, one in front of her face and the other aimed at her back. The background is overexposed by one and a half stops to render it light and gleaming.

Notice that the catch light in the eye is a reflection of an entire soft box – an effective finishing detail.

Photographer's comment

Genevieve's body was very light through make-up except for some blue highlights on her eyes, lips and breast.

use	Portfolio
model	Genevieve
stylist	Geni and Mike
camera	6x6cm
Lens	150mm
film	EPP 100
exposure	1/60 at f/11
lighting	Electronic flash

key points

Imaginative use of make-up can make for an imaginative subject and inspire an imaginative composition. Depth of field depends on several factors: the focal length of the lens, the distance of the subject from the camera, and the amount of light available, so in this shot f/11 is a relatively shallow depth of field

plan view

CROUCHING MAN

photographer **Frank Wartenberg**

use	Publicity
camera	6x7cm
lens	105mm
film	Fuji Velvia
exposure	Not recorded
lighting	Electronic flash

The key to this shot is a very shallow depth of field to make the model's head appear separate from the body.

black bounce *soft box* *background*

plan view

6x7cm camera *white reflector* *black bounce*

key points

Controlling a model's pose is not purely a compositional consideration, it is very much to do with lighting control as well

Depth of field is dependent upon the distance of the subject from the lens, the aperture and consequently the amount of light

The more one looks at it, the more surreal, and even disturbing, the shot seems to become. The lighting adds to the disembodied effect by emphasising graphic areas of light and shade. The pose is highly contrived; the lines on the forehead are there to create distinctive forms and the braced muscles also highlight the landscape-like undulations of the limbs.

The purpose of all this careful posing and composition is of course to establish the perfect crest of bristle-like hair at the point of focus, both in terms of the lens and in terms of the viewer's interest.

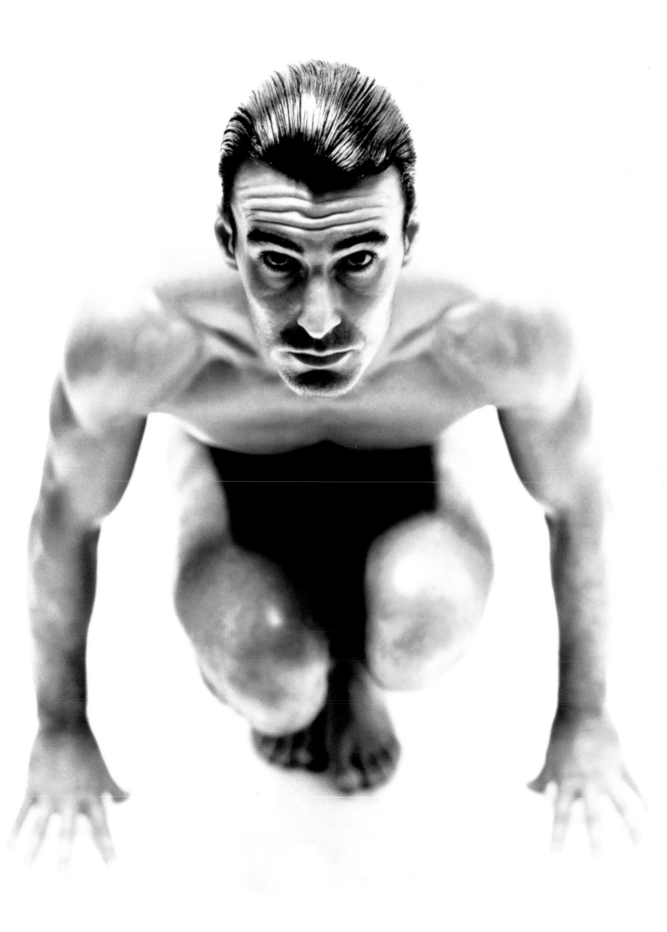

CHINESE HAIR

photographer **Frank Wartenberg**

use	Self-promotion
camera	6x7cm
lens	127mm
film	Fuji Velvia
exposure	Not recorded
lighting	Tungsten

There is no shortage of lighting equipment here. Frank Wartenberg has assembled an impressive array of soft boxes and silver styro reflectors, above, below and around the camera.

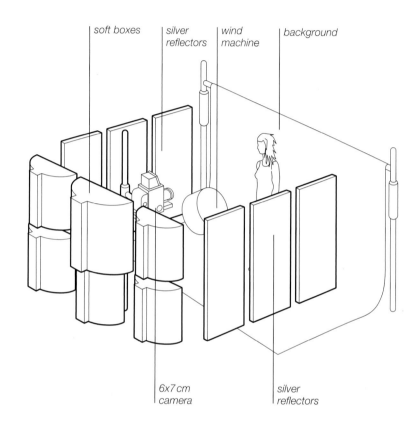

soft boxes *silver reflectors* *wind machine* *background*

6x7cm camera *silver reflectors*

plan view

key points

Modelling lights are normally tungsten, so remember this when balancing sources

Silver reflectors will produce more focussed light than white reflectors

The main light is a large soft box (used with the modelling light only) behind the camera. Six smaller soft boxes are arranged on either side and below this, again using only the tungsten modelling light. These combine to give an even sheet of light across the subject. On both sides is a selection of silver reflectors, effectively forming a wall to either side.

The resulting bright and even background provides a foil against which the strands of hair, tousled by the wind machine, stand out in stark silhouette.

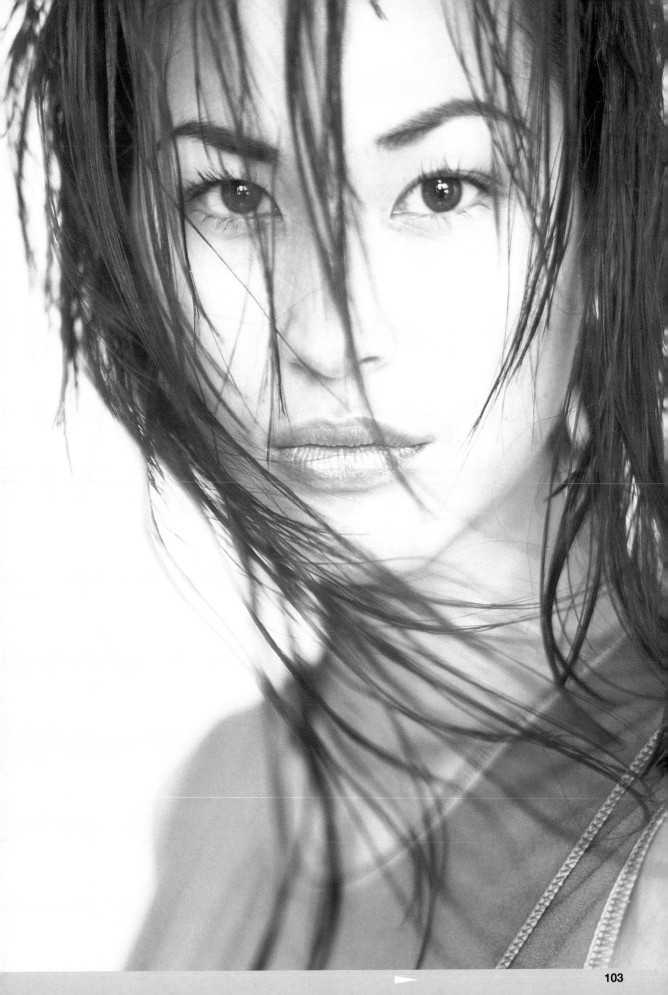

GIRL IN POOL

photographer **Bob Shell**

client	Stock
model	Sherri
camera	Mamiya 645
lens	180mm
film	Kodak E100S
exposure	1/60 second at f/16
lighting	Available light, electronic flash
props and background	Pool

The impressive cascade of carefully styled hair is a central point of interest and importance in this shot, the crowning glory, indeed, of this delightful model.

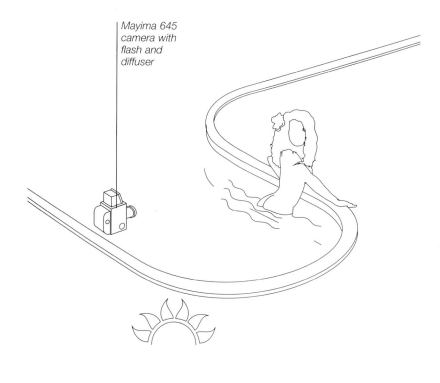

Mayima 645 camera with flash and diffuser

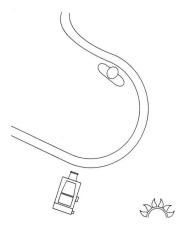

plan view

key points

A pool of water will act as a reflector and provide fill light from below

Rippling water can give a similar effect to a gobo used in a projection spot

The happy, summer days atmosphere of this shot is established not only by her minimal swimwear costume, flower-dressed hair and light-hearted pose and expression, but also by the lighting, which can make or break the desired mood and context of any such location shot. The available sunlight is enhanced and emphasised by Bob Shell's use of a portable flash with diffuser to lift the brilliance even further and give bright highlights on the body and face, while the shaded sides away from camera have a good rate of fall-off to give modelling and a clear sense of the curves of the model's figure.

The hair texture corresponds with the rippled waves of the water surface, and every strand is clearly and individually modelled in this area of the shot, drawing attention to the detail of the coiffure.

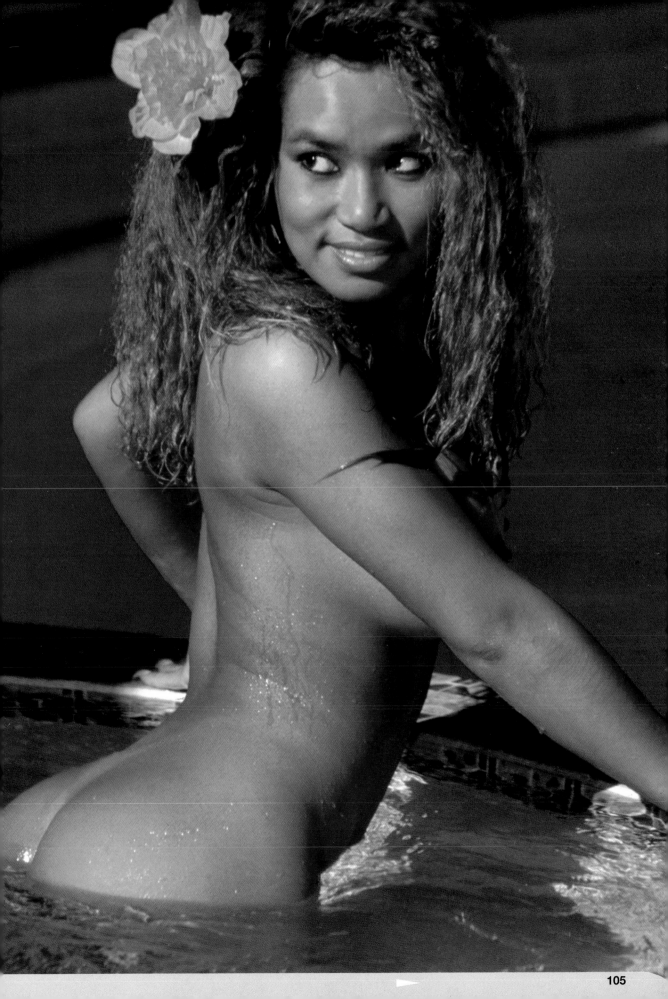

HAIR OVER FACE

photographer **Bob Shell**

use	Stock
model	Eva
camera	Mamiya 645
lens	180mm
film	Kodak E100S
exposure	Not recorded
lighting	Electronic flash
props and	
background	Lastolite background

Every strand of hair falls separately, thanks to expert styling, and the model's impressive mane of curls is arranged to create the maximum level of allure in this typically entrancing Bob Shell image.

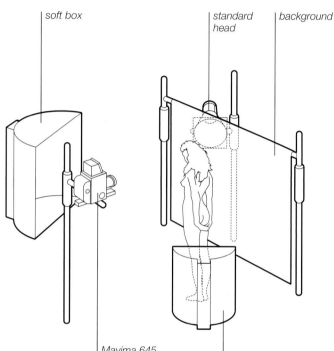

soft box

standard head

background

Mayima 645 camera

soft box

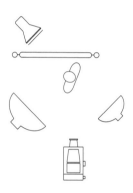

plan view

key points

Soft blanket light ensures no hard shadows from the hair fall on the face

A portable reflector is an essential part of any professional photographer's kit

The highlight in the model's eye is the focal point of interest and intrigue, a deliberate reflection of the large soft box on the left, which is also the key light. A small soft box on the right provides fill while the shimmering Lastolite background is lit by both the soft boxes. The standard head with small dish and purple gel coming from above the backdrop provides a backlight for the model, adding purple tones to the stray locks of hair to the left.

The fall-off area is on the skin surfaces straight on to the camera giving the deeper tanned skin tone along the near edge of the arm. The upper face, by contrast, has a constant soft blanket of light which is complemented by the highlights along the nose.

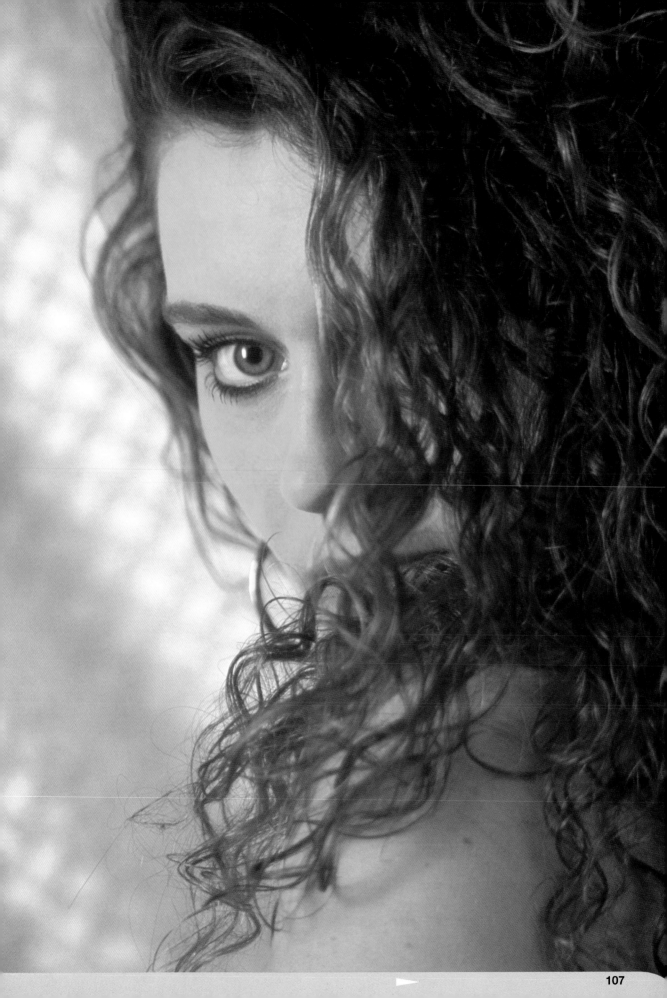

FACE

photographer **Isak Hoffmeyer**

client	Eurowoman
use	Editorial
model	Kati Tartet
assistant	Helene Elfsberg
make-up	Louise Simony
stylist	Bjorne Lindgreen
camera	Pentax 67
lens	90mm
film	Fuji Provia 400 ISO
exposure	1/2 second at f/2.8
lighting	Tungsten

The striking symmetry of this shot is part of what makes it so compelling. Equally arresting is the model's gaze, enhanced by bold make-up lines.

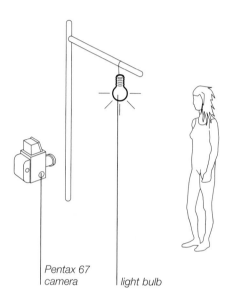

Pentax 67 camera

light bulb

plan view

key points

Symmetry of composition used in conjunction with symmetry of lighting can double the impact of a shot

Domestic tungsten lighting has a colour temperature of around 2800° Kelvin, which gives a warm, glow

Framing and punctuating the face are the all-important shadows below the chin, nose and brows, adding a strongly graphic and even geometric element to the composition. These shadows are achieved by the use of a single light source (in fact, a single domestic tungsten light bulb) positioned high above the model's head.

The model seems disarmingly close to the viewer and the resulting shallow depth of field flattens out all but the most important of her features. The evenness on the forehead and nose arise partly from this flattening-out effect, but also from the expert application of make-up to give a perfect silky smooth and even skin surface.

HAIR and MAKE-UP

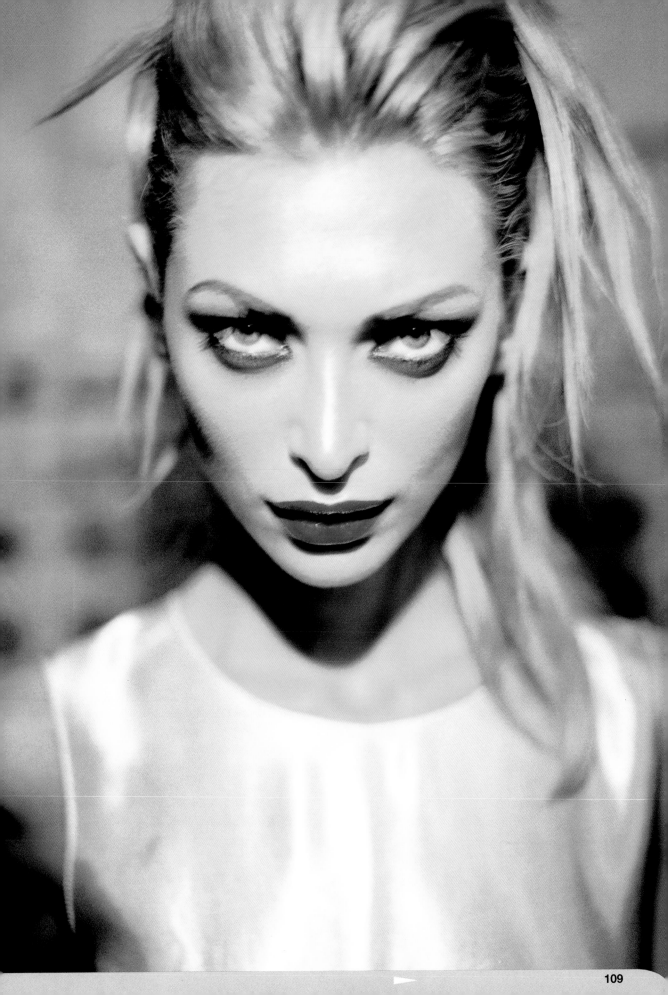

BIBA COVER

photographer **Jeff Manzetti**

client	Biba magazine
use	Cover
model	Estella Warren
hair	Karim Mytha
make-up	Brigitte Hymans
stylist	Nathalie Marshall
camera	Pentax 67
lens	135mm
film	EPT 120/160
exposure	f/4
lighting	Flash

In his shot, the photoragher, Jeff Manzetti, uses a highly controlled pool of soft light, and the key modelling is provided by one single direct source.

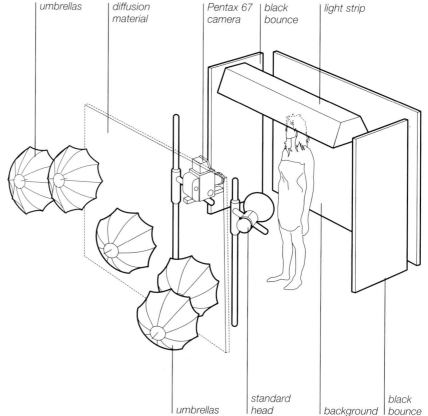

umbrellas diffusion material Pentax 67 camera black bounce light strip

umbrellas standard head background black bounce

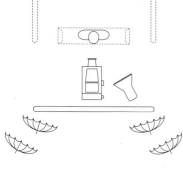

plan view

key points

Black panels will dramatically increase the fall off within a composition

Catchlights are an important consideration and should not be left to chance

Two pairs of heads shooting into brollies, are evenly placed either side behind the camera and come through a wall of diffusion material to provide overall illumination and light the background. A strip light is positioned directly above the model to pick out every single lock and wisp of hair. The placing of the key light is evident

from the dual catch light in the eyes. The leftmost catchlight is from the brollies, whereas the right hand side one is the key light. A standard head with a fresnel lens, just to the right of the camera, is set to give just enough modelling under the chin, but the pool of soft light keeps the depth of the shadows to a minimun.

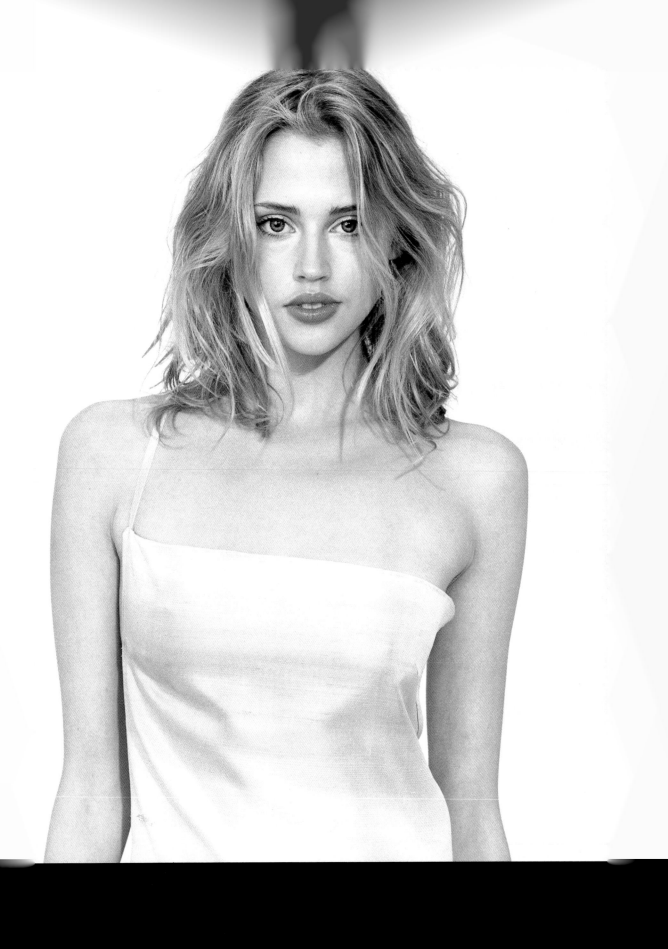

LINDA

photographer **Jörgen Ahlström**

client	Elle
use	Editorial
model	Linda
camera	6x7cm
lens	90mm
film	Kodak GPY 400
exposure	Not recorded
lighting	Daylight tubes

The straight line catchlights in the eyes reveal something of the lighting set-up that has been used for this classic cover-shot image.

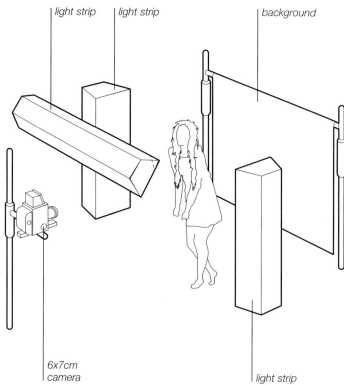

light strip light strip background

6x7cm
camera light strip

plan view

key points

Using a fluorescent tube instead of a strip light gives more concentrated light

Standard fluorescent tubes can be corrected to daylight by using a specific purple gel

Jörgen Ahlström used Kino Flo daylight tubes (fluorescent tubes balanced to a colour temperature of 5600° Kelvin, equivalent to that of a standard flash head and daylight).

The one that is reflected in the eyes is above the camera and horizontal to the ground. In this position it provides the catchlights in the eyes, emphasises the eyeshadow and lips and adds

general lighting across the front of the model. Two more daylight tubes are positioned upright, one either side of the model, in close proximity to her. These give the bright glare on the sides of the arms and highlights on the cheeks. The slight halo effect occurs because these tubes are just behind the model.

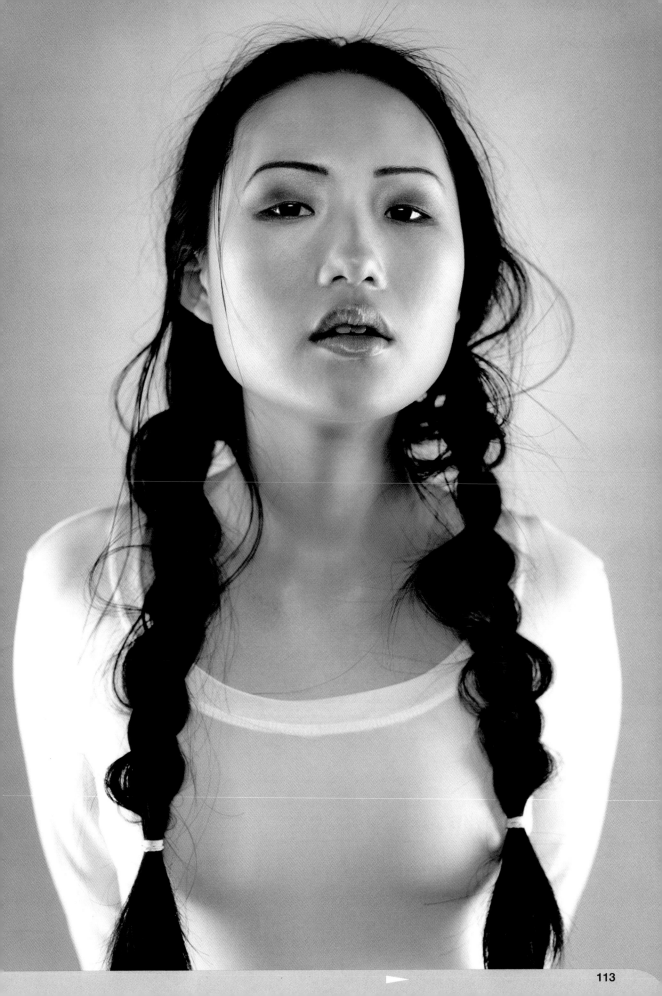

HAIR

photographer **Craig Scoffone**

use	Portfolio test
model	Allison
camera	35mm
lens	75-125mm zoom
film	Kodak Tri-X
exposure	Not recorded
lighting	Electronic flash
props and	
background	White background

Craig Scoffone chose the particular lighting set-up used here to make the most of the beautiful facial features of his model.

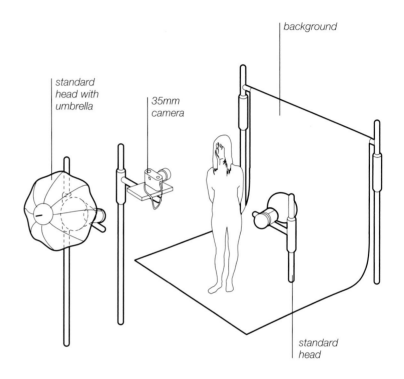

plan view

key points

Choosing the right model for the look you want is the first and most important decision and it is only rally this that is more important than the lighting

A good exercise is to light the same scene with different light sources, e.g. a direct standard head, a soft box, and an umbrella to gain a thorough understanding of the differences. Start with one light and then begin to add more

"The 44 inch silver umbrella was suspended by a boom arm directly above camera," he says. "A single strobe head was placed behind the subject for background illumination.

The single top-side light source helped define the subject's beautiful bone structure." The bold definition and modelling below the chin is the result of the high position of the key light. This also picks up the fine silvery texture of the wisps of hair across the face.

The background is lit by a standard head placed immediately behind the model but hidden from sight in the final image by the tight crop and the model's position.

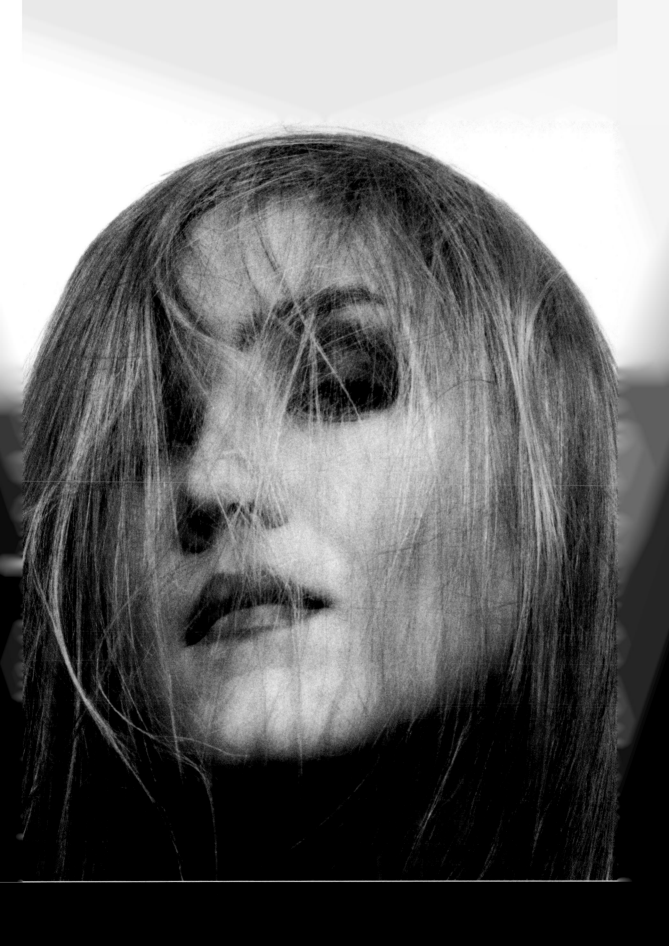

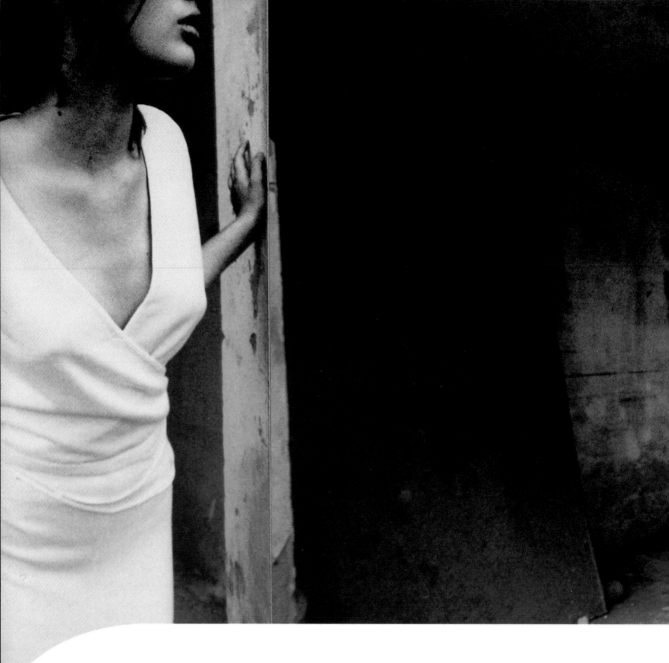

STUDIO FASHION

06

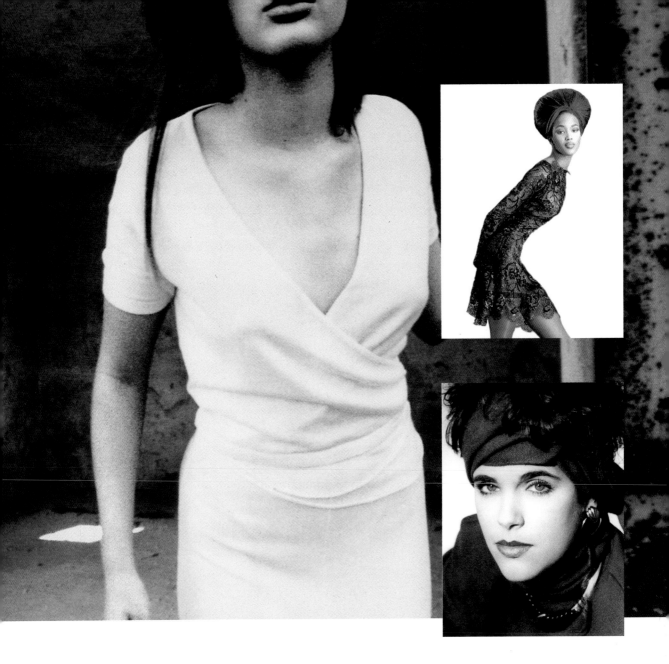

It is in the studio that the majority of new fashion images are created by the top photographers. This is because the studio offers full control over many of the factors that contribute to the final shot: the setting, background and styling can all be created as required, and, of course, the lighting is entirely in the hands of the photographer, who is not at the mercy of the vicissitudes of the outdoor weather conditions.

However, there is more to the studio fashion image than the lighting. The styling, make-up, clothes and accessories must all be just right. Equally important is the model, who must be directed well in order to elicit the performance and expressions that will give the shot the right look, and the posing that will show off the clothing in the way required. The studio keeps open a full range of possibilities for the photographer to realise what may be a tricky and subtle brief.

BOUCHE SUAVE

photographer **Jeff Manzetti**

client	DS Magazine
use	Editorial
model	Karine Saby
hair	Bruno Wepp
make-up	Thibault Fabre
stylist	Nathalie Baumgartner
camera	6x7cm
lens	135mm
film	Fuji EPL 160
exposure	1/30 second at f/4
lighting	Electronic flash

Even though it is quite clear that this is a photograph of lips, there is a way of looking at his image as though it were an abstract study.

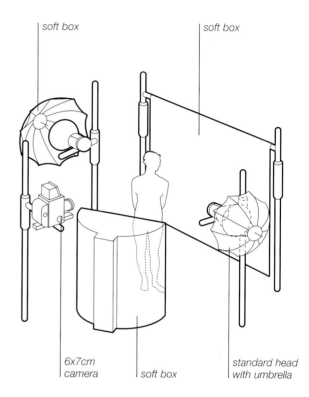

soft box *soft box*

6x7cm camera *soft box* *standard head with umbrella*

plan view

key points

When composing tight close-up images remember that space is required to place lights appropriately

Sometimes deliberately degrading an image (i.e. not shooting it ultra-sharp) can give a more interesting look

The effect of being so close in to the subject, with such a smooth, even expanse of pale colour in the areas of the face and the background, gives a sense of disembodiment and lack of context for the lips. It is simultaneously a very rounded rendering of the three-dimensional full pouting lips and also a flat, abstract, two-dimensional image of an area of shiny red against a pale background. It all depends how you look at it.

From a practical lighting point of view, it is desirable to have a long macro or long close focusing lens to allow for optimum positioning of lighting. This shot is lit by an Elinchrome octabox (an octagonal soft box) to the right of camera. The background is lit by two symmetrically positioned standard heads shooting into umbrellas.

BLACK SLIP/LACE DRESS

photographer **Wolfgang Freithof**

client	Fernando Sanchez
use	Editorial
models	Claudia Schiffer (Black slip) and Naomi Campbell (Lace dress)
art director	Quintin Yearby
make-up	Sam Fine
hair	Ron Capozzoli
camera	6x6cm
lens	150mm
film	Kodak Tri-X
exposure	1/60 second at f/8
lighting	Electronic flash

On this shoot, Wolfgang Freithof was working with the two great supermodels, Naomi Campbell and Claudia Schiffer.

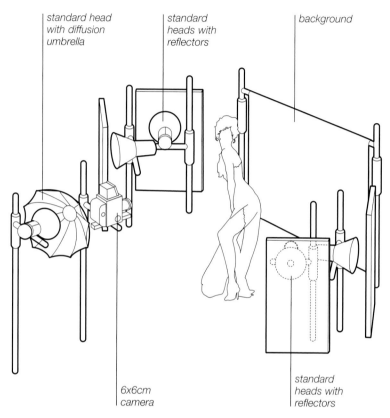

standard head with diffusion umbrella

standard heads with reflectors

background

6x6cm camera

standard heads with reflectors

plan view

key points

Before buying expensive computer equipment, make sure you know what you want to do with it

Images can put into a computer via a scanner or can be originated on a digital format

The poses of the two shots and the fact that they were created in the same shoot using the same lighting set-up and modelling fashions from the same collection seem to mark out the images a natural pair. Yet for all their similarities, the two pictures give some insight into the personal qualities that professional models can bring to their work. It is tempting to say that the poses are similar, but a closer look reveals that they are not: Naomi Campbell's trademark striding style is evident in the still, just as Claudia Schiffer's vampish, dramatic style comes through in her shot with equal strength.

The lighting used is straightforward. Two pairs of standard heads bounce out of a polyboard wedge on each side, and the key light is a standard head shooting through an umbrella above the camera.

photographer's comment

Retouched and coloured on an Apple 9600/300 with 320MB of RAM, 22 GB hard drive, using Adobe Photoshop 5.0

BELLY

photographer **Frank Wartenberg**

use	Publicity
camera	6x7 cm
lens	90mm
film	Fuji Velvia
exposure	Not recorded
lighting	Electronic flash

Ever one to use an innovative and imaginative lighting set-up, this shot shows Frank Wartenberg's individual approach to good effect, and demonstrates the superb results that he gets.

plan view

key points

Back light traditionally is a hard source, but of course rules are there to be broken

Experiment with different lighting set-ups, you may find something unexpected works very well

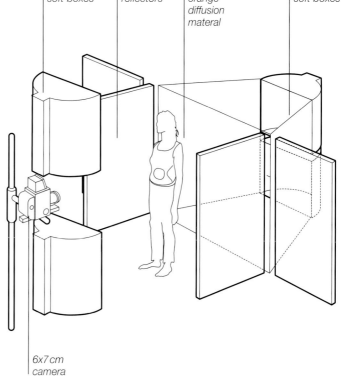

soft boxes reflectors orange diffusion materal soft boxes

6x7 cm camera

There are two soft boxes behind the model, stacked one above the other, directed towards the camera to back light the model. A large pair of panels painted orange provide a background behind the model and the soft boxes are behind these.

Face on to the model, are two more soft boxes, one positioned above the camera and one below. These give an even spread of light along the full length of the model. Two styro wedges act as reflectors to the sides.

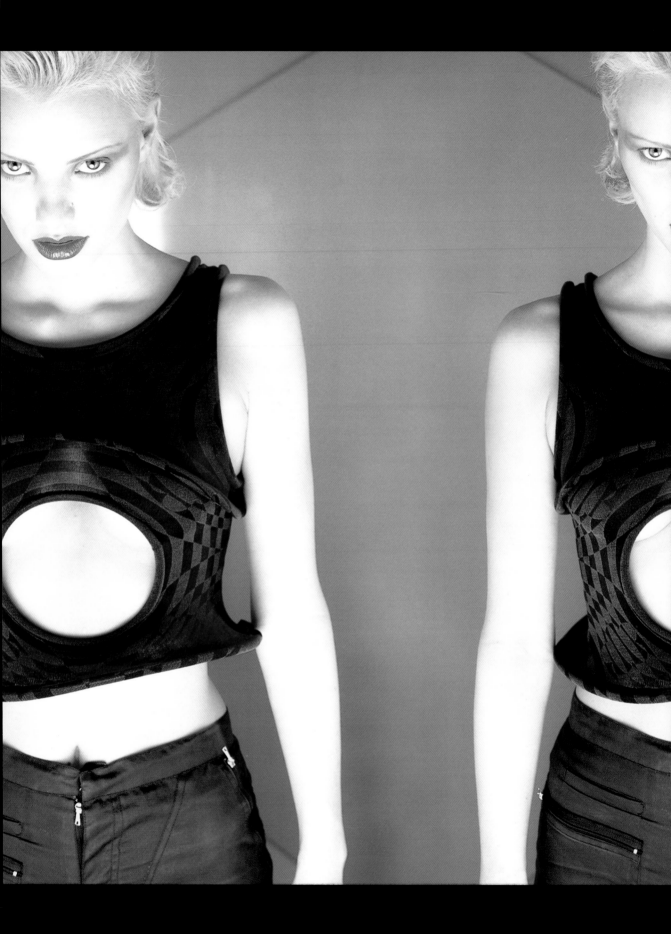

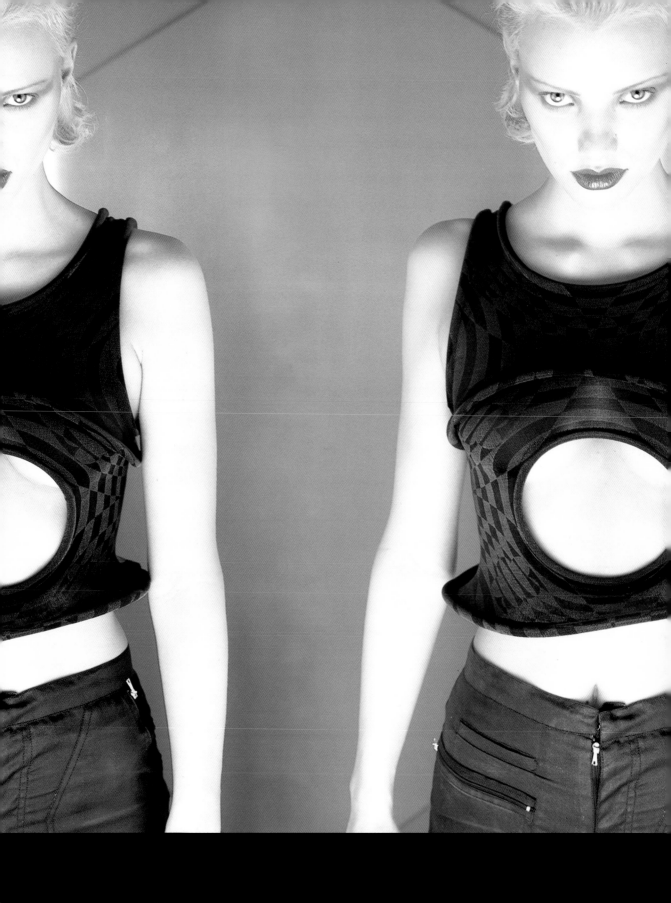

ALICIA

photographer **Craig Scoffone**

use	Model test
model	Alicia
camera	35mm
lens	75-125mm zoom
film	Vericolor VPS
exposure	Not recorded
lighting	Available light, skyscraper reflectors

"The subject was posed in a pool of light created from the direct light of the sun," explains photographer Craig Scoffone, **"reflecting off the glass of the skyscraper across the street from where we were shooting."**

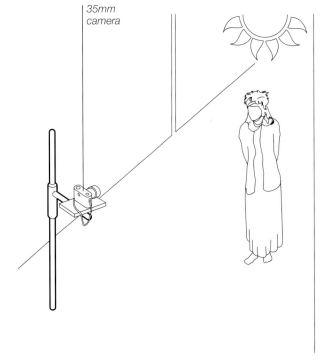

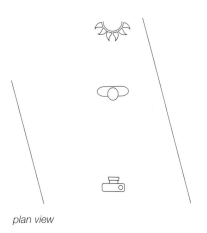

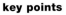

plan view

key points

Observing naturally occurring lighting situation can be inspirational when working back in the studio

Many different things can be used as reflectors, from small make-up mirrors and silver-backed plasterboard to skyscrapers and cloud formations

There is quite well defined amount of modelling beneath the chin because of the high angle of the sun. The front of the face is very brightly and evenly lit to give a smooth, flattering look. It is an interesting technique to use a large-scale city street as a studio and well-placed reflective skyscrapers as lighting equipment: Craig Scoffone attributes the main light source to the reflected sunlight from the large skyscraper to camera left and credits the smaller skyscraper to the right for acting as the secondary source with a gobo effect. This technique, albeit on a large scale, is basically that of shining a point source into a mirror.

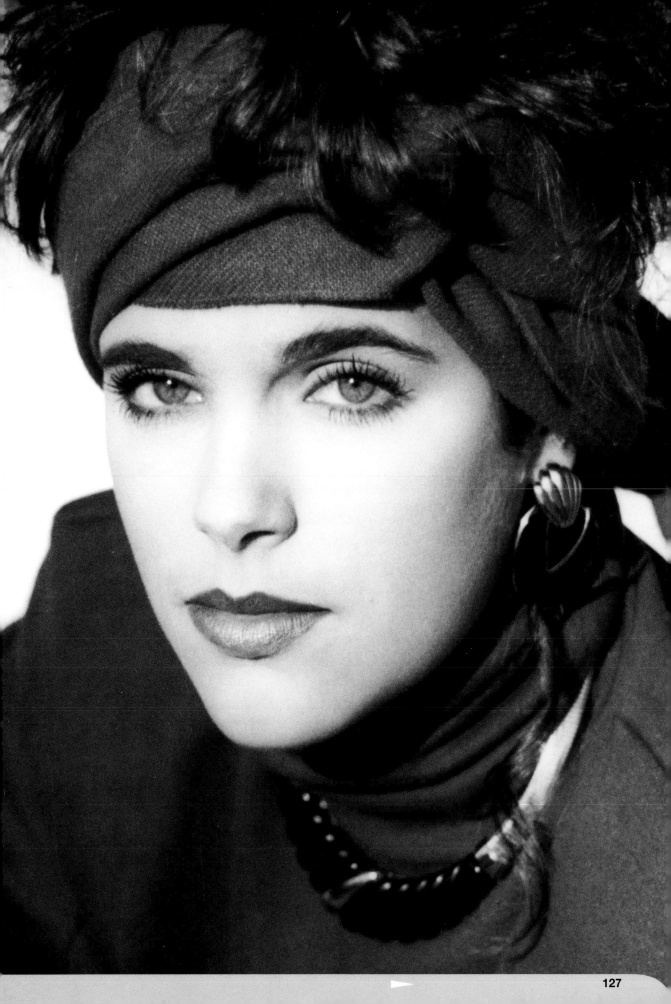

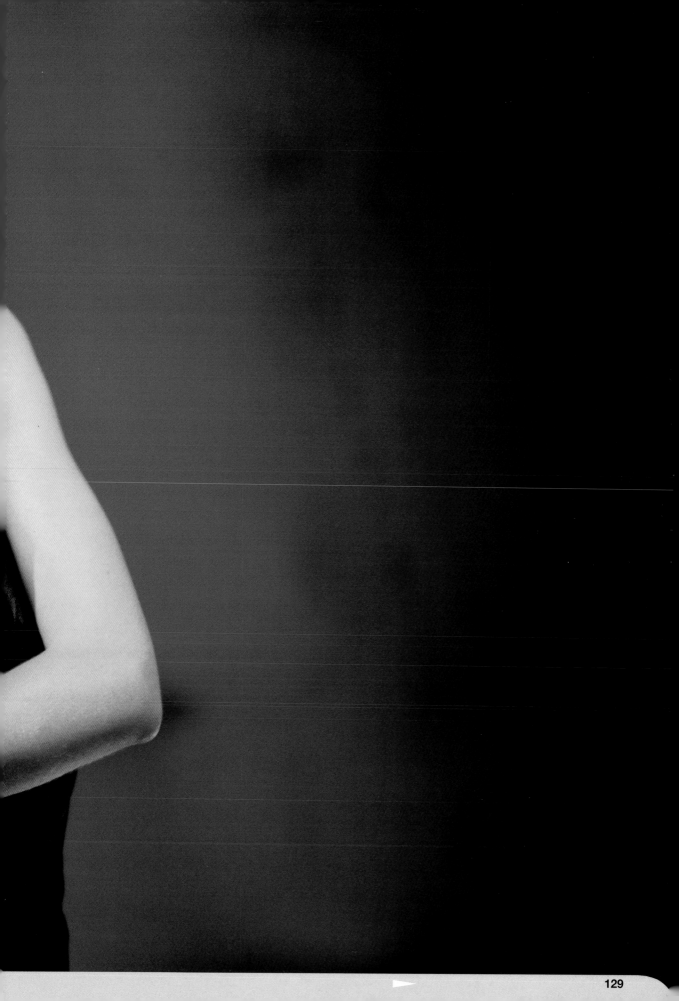

BLACK DRESS

photographer **Isak Hoffmeyer**

client	Eurowoman
use	Editorial
model	Kati Tartet
assistant	Helene Elfsberg
make-up	Louise Simony
stylist	Bjorne Lindgreen
camera	Pentax 67
lens	90mm
film	Fuji Provia 400 ISO
exposure	1/2 second at f/2.8
lighting	Tungsten
props and	
background	Painted backdrop

Effective lighting does not have to be expensive and difficult. For this shot, the lighting set-up consisted of nothing more than what Isak Hoffmeyer describes as "a lightbulb on a stick!"

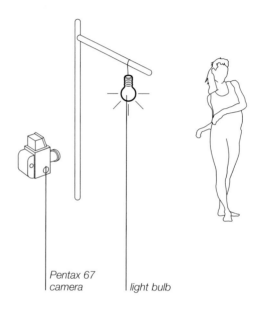

Pentax 67 camera light bulb

plan view

key points

When cross-processing film stocks it is essential to perform extensive tests to establish film speed rating and development time

Different types of lighting are affected in different ways by cross-processing, but generally there will be an increase in contrast

Of course, it is not so much what you've got as what you do with it that counts – in other words, the use to which the lighting is put indicates the skill of the photographer, rather than the grandeur (or otherwise) of his equipment.

In this case, Isak has got a great deal out of very little. The bulb is suspended high above the camera and slightly to the side to give a degree of directionality to the light. (The angle of the shadow on the throat indicates the height and position of the bulb clearly.)

The model is some distance from the backdrop, which is adequately illuminated by the same source. The choice of costume, pose, glossy make-up and positioning of light and camera make the most of specular highlights at various points, for interest. Notice the slight softness that is evident in the shot, inevitable with a half-second exposure. It, too, is a carefully considered element and adds to the image's sense of dynamic movement.

WHITE DRESS TWICE

photographer **Corrado Dalcò**

client	Bruno's Knitwear
art director	Vignali Augusto
assistant	Daniele Ferrari
stylist	Olivia
hair	Matteo
use	Editorial
camera	35mm
lens	24mm
film	Ektachrome 64
exposure	1/60 second at f/2.8
lighting	Available light

It is interesting to compare this pair of shots with another of Corrado Dalcò's: his "Architecture" shot which appears in the final chapter of this book.

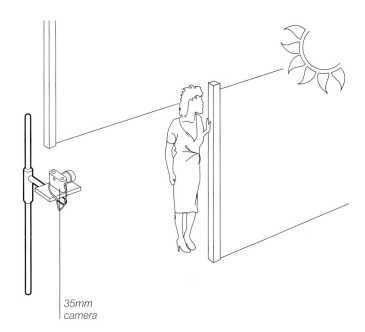

35mm camera

plan view

key points

Rules are there to be broken, in terms of composition as much as in lighting

Experiment with different methods of presentation to enhance the impact of an image

The impact and effectiveness of using a pair of shots for a single fashion feature comes across clearly. It is an interesting and useful technique to keep in mind, adding interest and a sense of a viewer experiencing a "double take" on the subject photographed.

In contrast with "Architecture" however, this pair of images has the opposite cross-processing technique applied. In this case, E6 film has been processed in C41 chemistry. Notice the contemporary compositional technique used. The cropping halfway through the head might be misconstrued: in other circumstances be the signature of an unskilled amateur, but it is quite deliberate here and is actually surprisingly difficult to compose and frame so precisely in this way. There is a vogue for framing of this kind in current fashion imagery in order to emphasise the clothing and give a stark, harsh "street" grittiness to the shots.

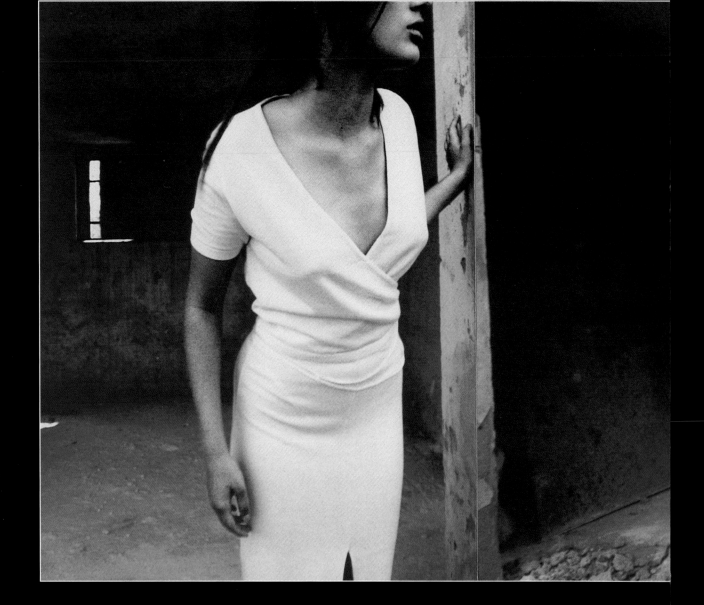

STUDIO FASHION

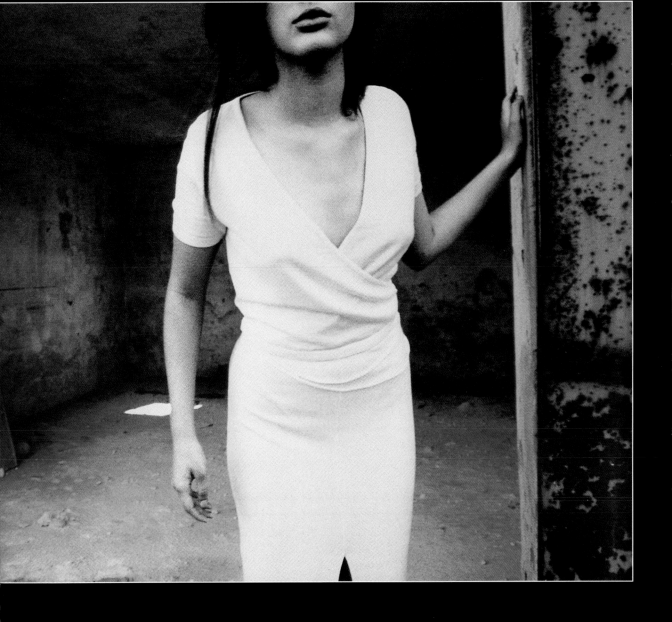

FASHION for FUN

07

The shots in this chapter come from a wide range of quirky starting-points. In some, it is the clothing itself which sets the light-hearted tone of the shot. In others, relatively unostentatious outfits are modelled in an energetic and amusing ways as in Simon Clemenger's 'High Kick', for example. Finally, there are those shots which demonstrate the photographer's sense of humour and off-beat imagination, such as Frank Wartenberg's 'Gold boots'.

Imagination is perhaps the most powerful tool at the disposal of the talented photographer; it is an asset that sets the superb apart from the technically able, for technical ability can be learned whereas imagination comes from within. The unexpected images in this chapter are an inspiration and a joy in their fresh and innovative approach to the familiar world of the fashion shot.

HIGH KICK

photographer **Simon Clemenger**

use	Model portfolio
model	Sophie
make-up	Caroline
stylist	Siobhan
camera	RZ67
lens	50mm
film	Kodak GPH
exposure	Not recorded
lighting	Electronic flash
props and background	Infinity cove

The model is in the heart of an infinity cove with a soft box at either side of her angled into the curvature of the cove.

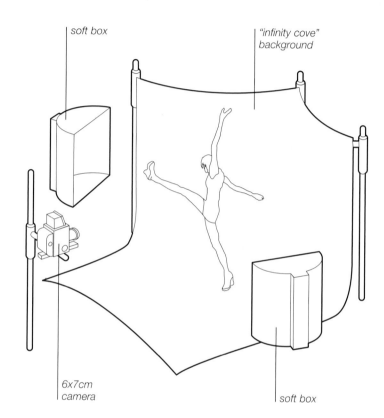

soft box

"infinity cove" background

6x7cm camera

soft box

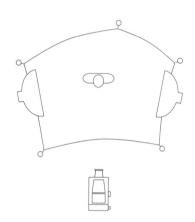

plan view

key points

This is a classic example of a background acting as a reflector

Colour negative stock has far more latitude than transparency stock

In effect she is in a pool of direct and bounced soft light, since the positioning of the soft boxes means that the cove itself acts a reflector and doubles up the two sources into four (i.e. two direct sources and two bounced sources simultaneously).

This results in a very even spread of light right across the subject, with a minimum of modelling. The effect is to make the model look free in space, with a strong sense of her movement and very little sense of place or space around her to distract from this core idea. Although not hand-trimmed, the image has the same crispness and lack of context as the neatest of cutouts.

photographer's comment

I wanted to capture a sense of freedom of movement.

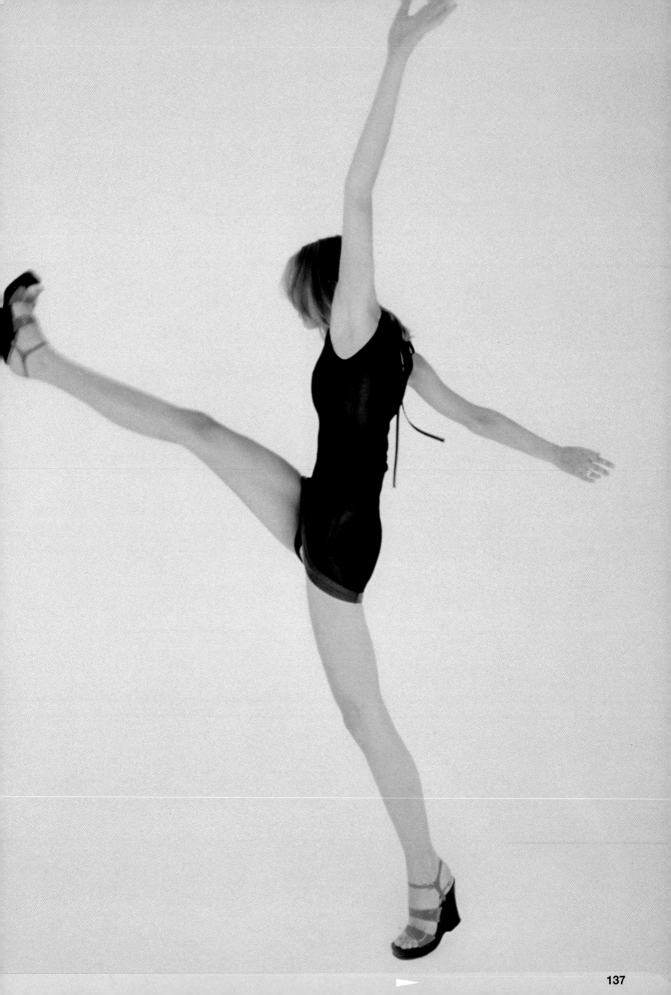

FASHION for FUN

ARCHITECTURE

photographer **Corrado Dalcò**

use	Personal work
model	Reka
assistant	Francesca Passeri
art director	Corrado Dalcò
hair	Caterina
camera	35mm
lens	24mm
film	Fuji Realla 100
exposure	1/8 second at f/2.8
lighting	Tungsten

The unusual background for a shot is, in fact, the decor of the house of a friend of photographer Corrado Dalcò.

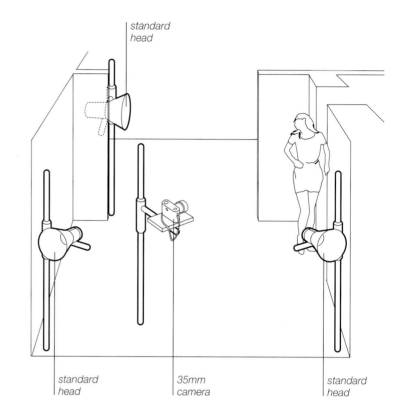

standard head

standard head

35mm camera

standard head

plan view

key points

It is worth keeping a good log of unusual location settings that you happen to come across for use in future shoots

Lighting effects can be achieved by background paintwork and set-dressing rather than by actual lights

The background gives the effect of rays of light as if streaming down from the sun in a child's painting, whereas in actual fact the effect stems from the architectural element of the title.

Of the three tungsten standard heads used to light this pair of shots, only one is used as a direct source. That is positioned well back to the left of the camera and acts as a source of illumination on the background. The other two tungsten heads are one directly behind and one to the right of the photographer and bounce off the walls of the building. The cross-processing lends the unusual colour rendition associated with the technique.

FUTURISTIC

photographer **Frank Wartenberg**

use	Publicity
camera	6x7cm
lens	90mm
film	Fuji Velvia
exposure	Not recorded
lighting	Electronic flash

plan view

key points

The mix of unmatched light source types can be actively embraced for a particular look

It is a good idea to keep a range of higher output domestic lamps to help balance exposure

The secret of handling a set-up of this complexity successfully is to consider each element individually, and then take account of the cumulative effect and the inevitable inter-relations of all the sources.

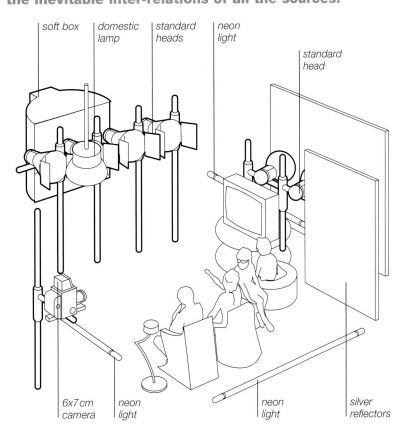

The lights within the shot come first and the other elements have to be arranged to accommodate them. Within frame here are an overhead domestic tungsten lamp, an illuminated TV screen and various neon strips, some of which are blocked from direct view of the camera.

These set the parameters, and then Frank Wartenberg has added an array of spots, one per model and a large soft box for broader model illumination. The variety of source types and positions create the eerie futuristic look.

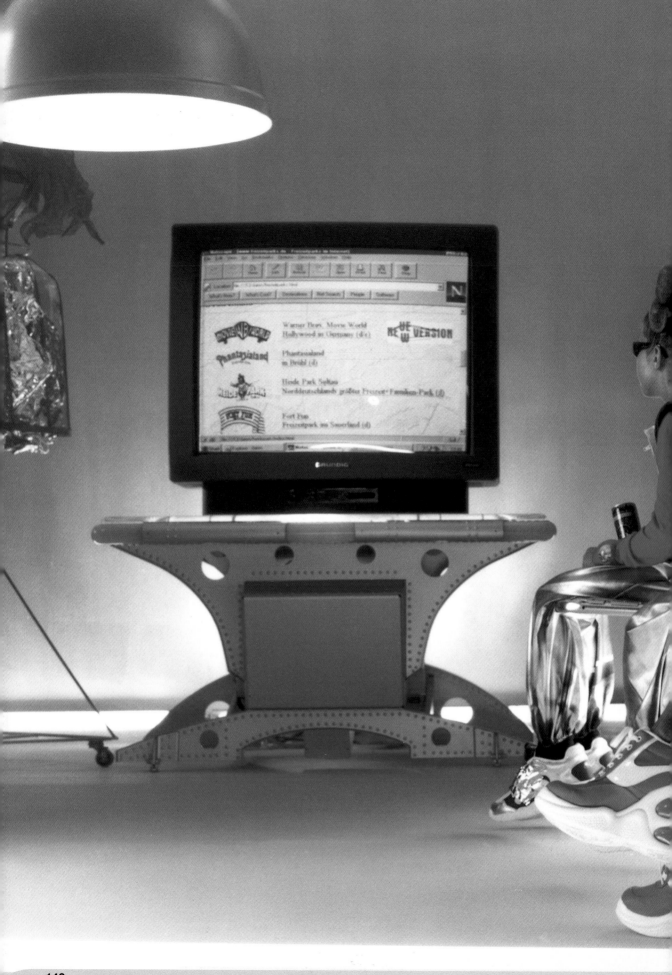

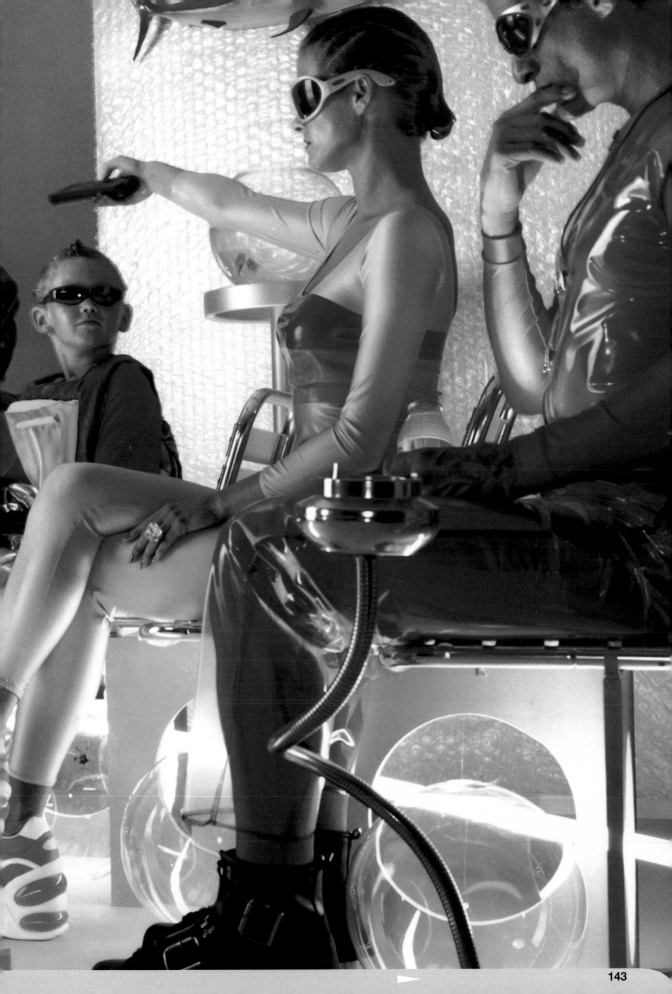

GIRL AND MASK

photographer **Wolfgang Freithof**

client	Sophia Lee for Ann Taylor Loft
models	Marcella and Zoli
make-up	Sidney Jamilla
mask by	Doug Chess
camera	6x6cm
lens	50mm
film	Kodak EPL
exposure	1/15 second at f/8
lighting	Electronic flash
props and background	White cove

Two standard heads pointing into two flats on either side of the models illuminate the background and the side of the models.

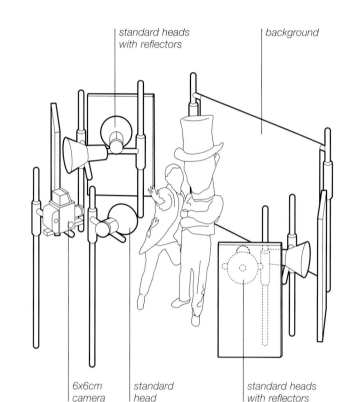

standard heads with reflectors

background

6x6cm camera

standard head

standard heads with reflectors

plan view

key points

Working in heavy or cumbersome masks and costumes can be very hot work – bear this in mind and give the models frequent breaks

Cut-outs can be managed digitally or manually, but can be tricky to do well either way

A standard head is high on a boom in the centre near the camera. The background light is one stop brighter than the front light, the effect of which is strong side lighting and background light. The evenness of the light on the background is a very deliberate choice in order to minimise the setting behind the models and give them an out-of-context, almost flying, look. From a practical point of view, if it is desired to cut out the image of the models and place them onto an alternative background later, this is more easily done if the original background is simple and plain and does not interfere with the process.

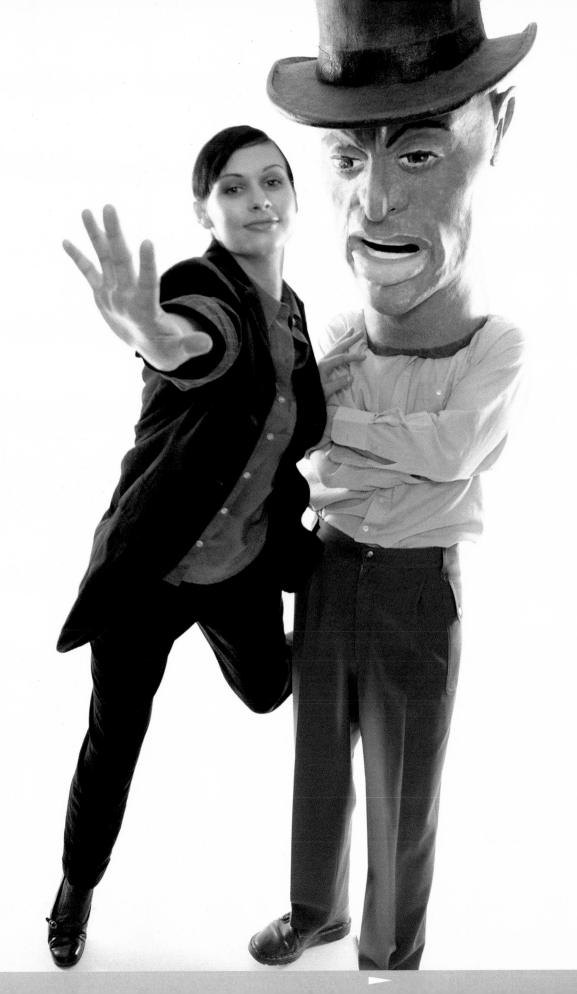

ELENA AND FISH

photographer **Wolfgang Freithof**

use	Editorial
model	Elena /Jan Alpert Models
art director	Sophia Lee
make-up	Nikki Wang
camera	35mm
lens	50mm
film	Fuji RDP
exposure	1/15 second at f/2.8
lighting	Available light, electronic flash
location	Jake's Fish Store

The choice of situation within the fish store location is important in order to capture the fish logo in the window in the background as a counterpoint to the actual fish in the model's hands.

35mm camera with ring flash

plan view

key points

When working with unknown light sources such as neon or argon lights, it is wise to make test exposures to determine how the colour records

Ring flashes provide very interesting catch lights

The blue bar and lines of the of the counter contribute an important graphic element, coupled with the diamond floor tiles which reflect in the rest of the counter.

The neon lights in the background provide some separation. The fluorescent lights which light the fish store generally have the usual green hue and Wolfgang Freithof has chosen not to compensate for this tinge, but rather to embrace the look, which contributes to the somewhat surreal feel of the image. The ring flash on the camera lens lights the model and the fish and this flash overrides the fluorescent lighting. The redness of the dress, lips and fish body and eyes are thus untainted by the green tinge but sing above the background tones in a startling and eye-catching way. They alone in the shot have the daylight quality of lighting and colour, and this looks quite unearthly set against the fluorescent ambient light of the rest of the image.

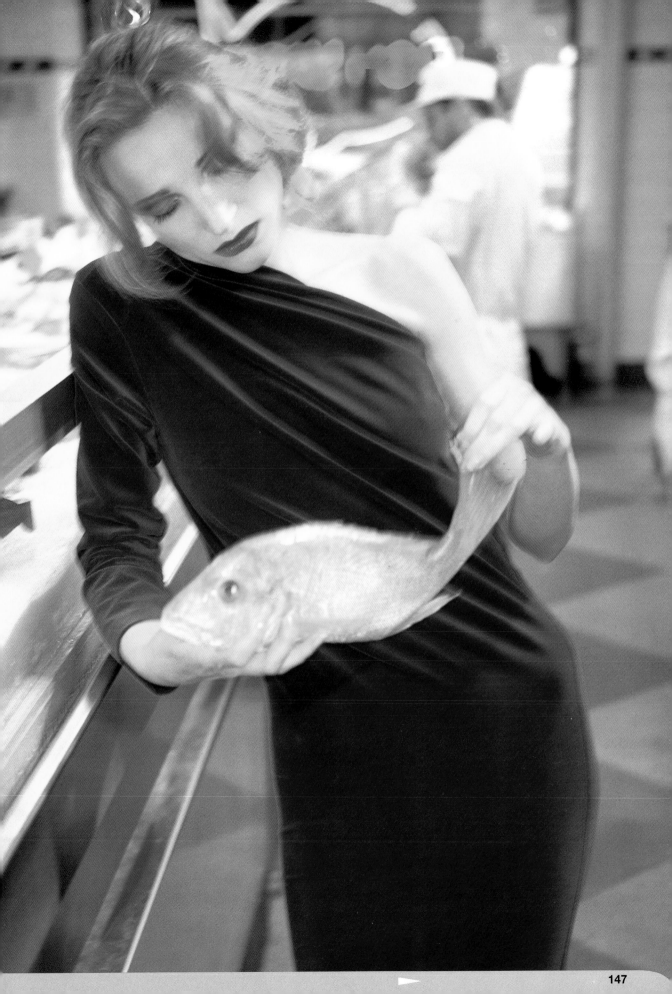

GOLD BOOTS

photographer **Frank Wartenberg**

use	Publicity
camera	6x7cm
lens	105mm
film	Fuji Velvia
exposure	Not recorded
lighting	Electronic flash
props and	
background	Golden background

This shot draws on many different inspirations. The hair is Medusa, the hands and arms are Hindu deity and the gold boots and shorts are a Midas touch of pure kitsch.

silver reflector *round soft box* *6x7cm camera* *gold background*

silver reflectors

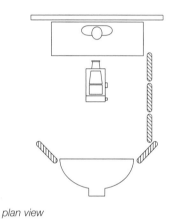

plan view

key points

When using a separate light meter, remember to take into account light lost by using a filter

Some reflectors focus light, some disperse light and others reduce light

The material and contours of the boots are great for introducing a playful element into the lighting, which is sourced simply by a large circular soft box directly behind the camera. To provide some modelling, a series of silver reflectors placed on the right of the camera, focus the spill light in to key the shot. As if the gold background, gold floor and gold costume and make up weren't enough, Frank Wartenberg really presses the point home by using an 81B warm-up filter.

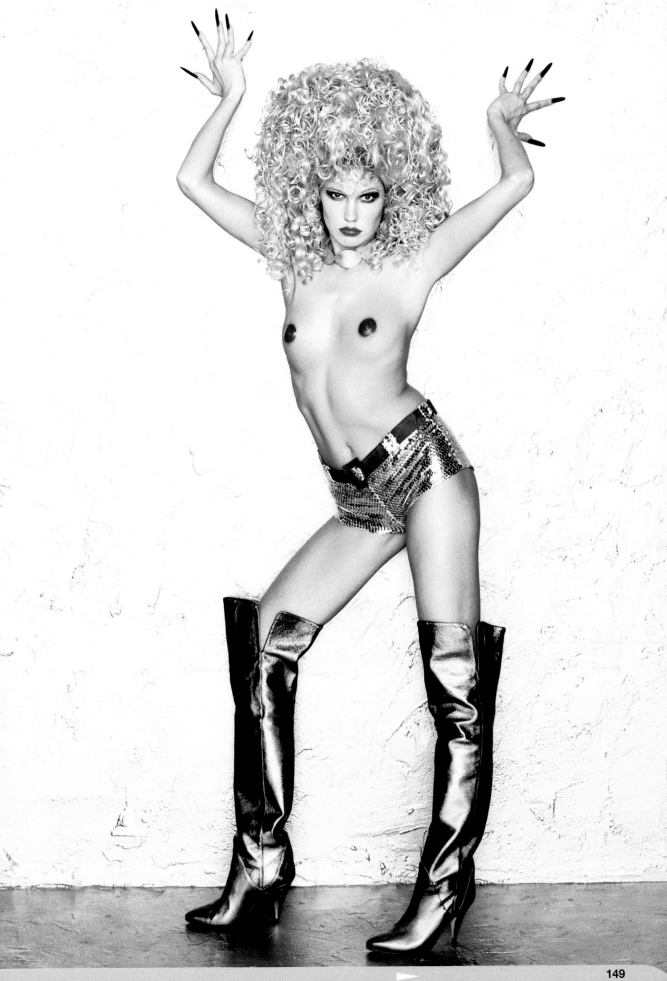

UNEXPECTED APPARITION

photographer **Renata Ratajczyk**

client	Stock use
hair	Chris Dwaywe
	(CPB Studio, Toronto)
camera	35mm
lens	35-105mm zoom
	(short telephoto)
film	Konica 3200
exposure	Not recorded
lighting	Tungsten, available light

This ghostly apparition image is the result of combining two shots in the darkroom. The main image of the model is in a standard studio set-up, shot against a white background.

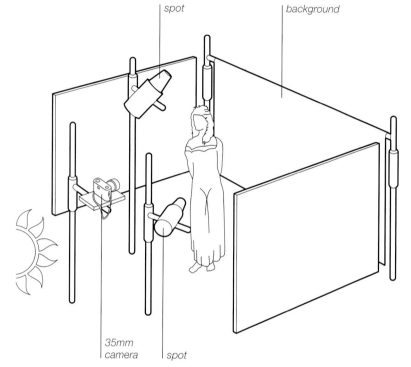

spot

background

35mm
camera

spot

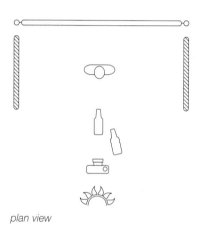

plan view

key points

The background image looks like colour infrared film but this effect might equally well be achieved by filtration during colour printing.

Behind the camera diffused light comes in through the window. The white walls on either side of the model bounce in available sunlight. Above the camera, directed into the low white ceiling, there is a small tungsten light and to the right of the camera there is a tungsten light with snoot and diffuser pointing directly into the model's face. It is this combination of tungsten light with daylight on a daylight-balanced stock that gives the warmth to the image of the model.

The choice of textures in the costume and colours throughout add to the unearthly feel of the shot. Additionally, the translucent over-bright and deliberately over-exposed look also contribute to the ethereal mood.

photographer's comment

This image was combined in the dark room from two negatives. The background image looks like colour infrared film but this effect might equally well be achieved by filtration during colour printing.

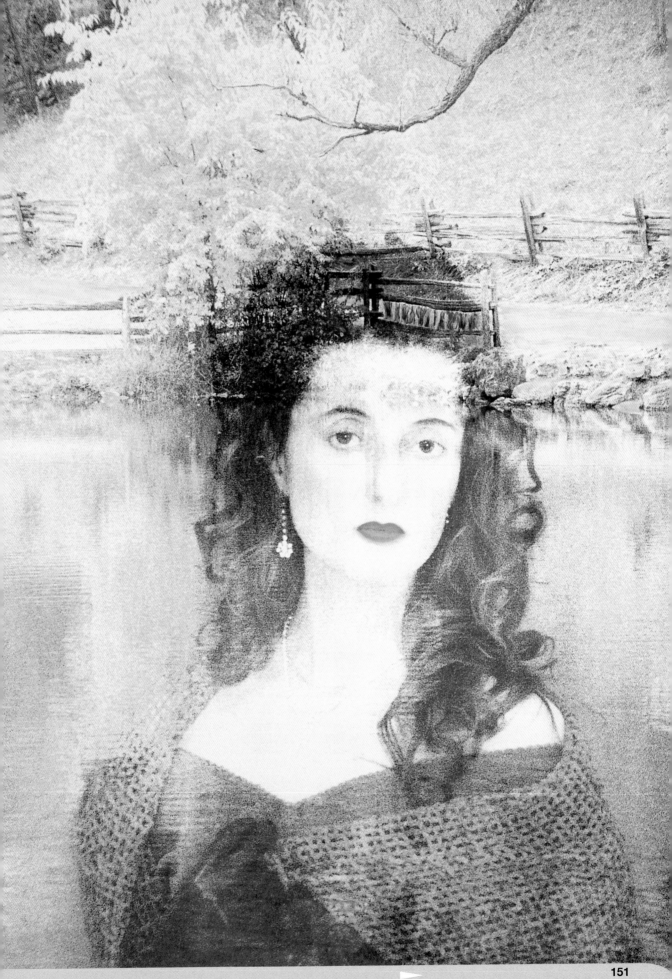

MIAMI FASHION

photographer **Michael Grecco**

client	Raygun Publishing
use	Editorial
models	Luna and Michael Grecco!
assistant	Jason Hill
camera	6x7cm
lens	50mm
film	Kodak EPZ 100
exposure	1/60 second at f/8
lighting	Electronic flash
props and	
background	Shot on location at Diesel Jeans Penthouse at the Pelican Hotel, Miami Beach, Florida

Michael Grecco made good use of this mirror-tiled wall to create this piece-meal effect image that is reminiscent of some of the famous collage work of David Hockney.

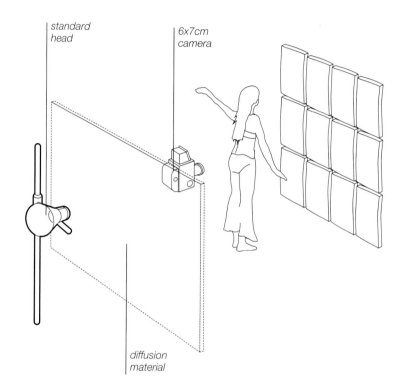

standard head

6x7cm camera

diffusion material

plan view

key points

Location features can provide a stimulus for a composition

If it is impossible to work around a feature that is a problem, try incorporating it into the idea instead

When working in close proximity to mirrors the photographer can either try very hard not to be seen and to hide lighting equipment, or can choose to make a feature of allowing all these things to be clearly visible in the final shot and play a part in the composition.

The lighting is provided by a standard head which is bouncing off a white wall at the opposite end of the room to the mirror. To diffuse the light, reduce the contrast and to produce a 'sheet' of light, a literal sheet of white silk is draped in between the model(s) and the light. The mirror gives some frontal light and also enables us to see the strong back light.

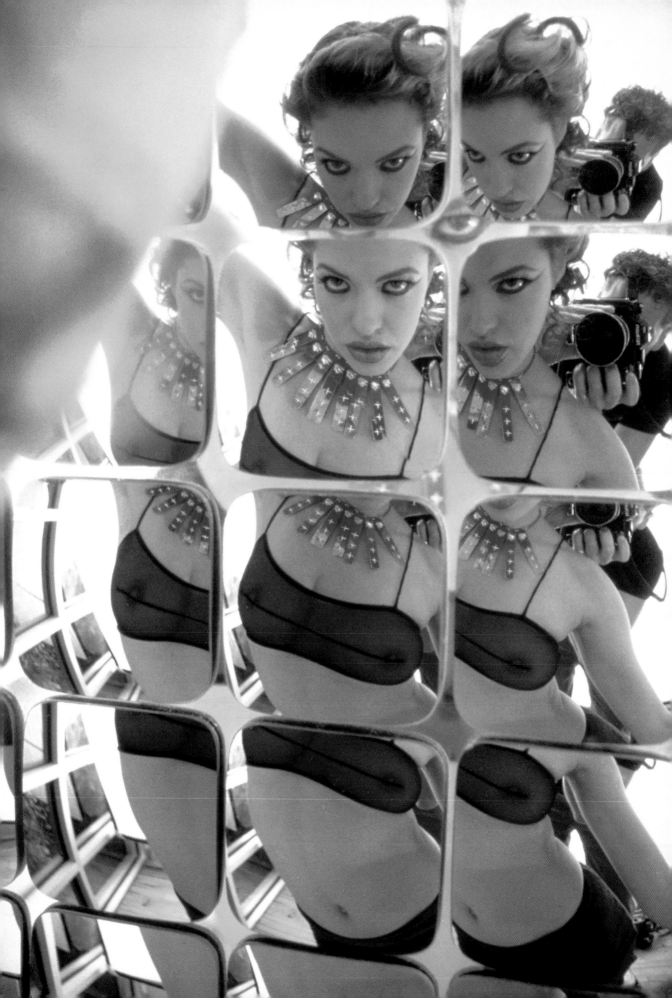

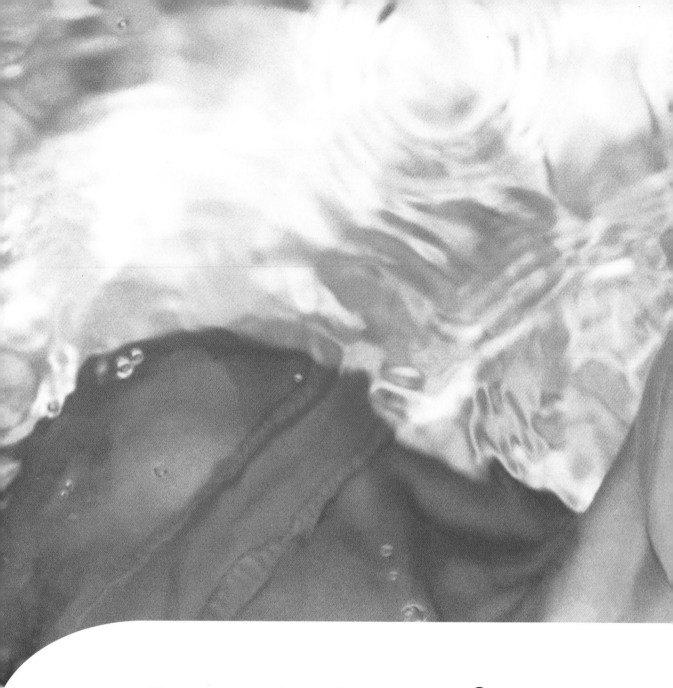

DIRECTORY of
PHOTOGRAPHERS

08

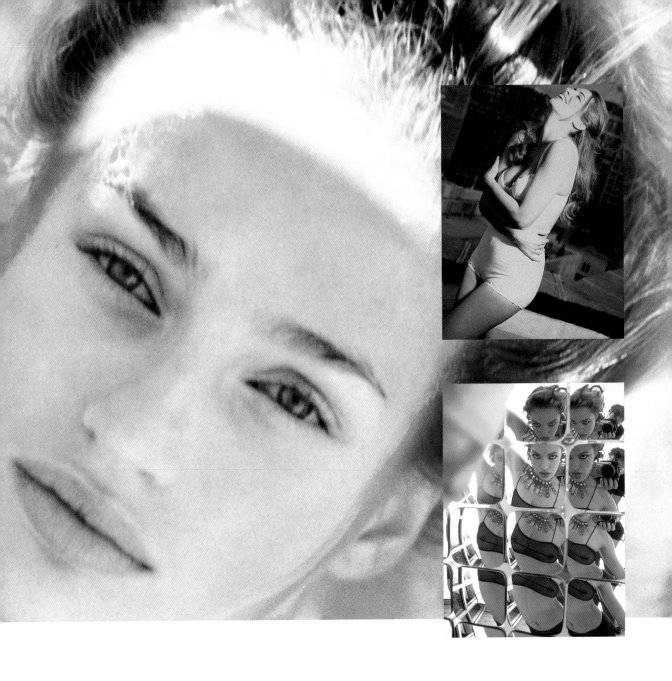

photographer	**Jörgen Ahlström**
address	Norr Mälarstrand 12
	112 20 Stockholm
	Sweden
telephone	+46 (8) 650 5180
fax	+46 (8) 650 5182
agent	The Purdy Company Ltd
(England)	7 Perseverance Works
	38 Kingsland Road
	London E2 8DD
	England
telephone	+44 (0)171 739 3585
fax	+44 (0)171 739 4345

pp: 80, 113, 53, 93

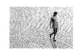

photographer	**Ben Lagunas and**
	Alex Kuri
studio	BLAK PRODUCTIONS
address	Galeana 214 Suite 103
	Toluca, Mexico
	C.P. 50000
telephone	+52 (72) 15 90 93
	+52 (72) 17 06 57
fax	+52 (72) 15 90 93
biography	Ben and Alex studied in the USA and are now based in Mexico. Their photographic company, BLAK PRODUCTIONS also provides full production services such as casting, scouting, models, etc. They are master photography instructors at Kodak Educational Excellence Center. Their editorial work has appeared in international and national magazines, and they also work in fine art, with exhibitions and work in galleries. Their commercial and fine art photo work can aslo be seen in the *Art Director's Index* (Rotovision); *Greatest Advertising Photographers of*

Mexico (KODAK); the ProLighting Series (*Nudes, Protraits, Still Life, Night Shots, Intimate Shots, Beauty Shots, Fashion Shots, Erotica* and *New Product Shots*); and other publications. They work around the world with a client base that includes advertising agencies, record companies, direct clients, magazines, artists and celebrities.

pp: 26, 83

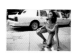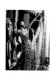

photographer	**Simon Clemenger**
address	1 Anchor House
	Old Street
	London EC1V 9JL
	England
telephone 1	+44 (0)958 71 71 50
telephone 2	+44 (0)1635 28 13 44

pp: 87, 47, 137

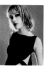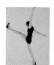

photographer	**Corrado Dalcò**
address	via Sciascia 4-43100
	Parma, Italy
telephone	+39 521 272 944
fax	+39 521 778 8434
email	imadv@mbox.vol.it
biography	Corrado Dalcò was born in 1965 in Parma. He studied for five years at the P. Toschi Institute of Art in Parma, specializing in graphic design. He is a self-taught photographer, working as a freelance photographer abroad before founding his own

photographic studio in 1991. He won an international competition in 1993 ("5ième Biennale") for young Italian photographers and his photos were published in the Photo Salon Catalogue. At present, Corrado works mainly with agencies in Milan, concentrating on fashion. Some of his work is also published in several Italian and international magazines.

pp: 132, 138

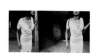

photographer	**Gérard de Saint-Maxent**
address	8, rue Pierre l'Homme
	92400 Courberoie
	France
telephone	+31 (1) 4788 4060
biography	Has worked in advertising and publicity since 1970. Specialises in black and white.

pp: 29

photographer	**Wolfgang Freithof**
studio	W. Freithof Studio
address	342 West 89th Street 3
	New York, New York
	USA 10024
telephone	+1 (212) 724 1790
fax	+1 (212) 580 2498
biography	New York-based freelance photographer with international clientele spanning a wide range of assignments from fashion, advertising, editorial, record covers to portraits, as well as fine art gallery shows.

pp: 120, 145, 61, 89, 147, 63

Photographer **Michael Grecco**

studio Michael Grecco
Photography, Inc.

address 1701 Pierave
Santa Monica, California
USA 90405

telephone +1 (310) 452 4461

fax: +1 (310) 452 4462

biography Michael Grecco has an
extensive background as an
editorial and advertising
portrait photographer. Along
with his advertising work for
Paramount, Fox, UPN, USA
Network and Warner Bros.,
Michael does regular
assignments for *Entertainment
Weekly, GQ, Movieline,
Playboy, Time* and many
others. He has been in *Photo
Direct News* three times, most
recently in June 1997. Michael
has also been featured twice in
American Photo, including a
piece on his provocative
Movieline Teri Hatcher cover
shot (April 1997). He has won
numerous awards for his work
including 1995, 1996 and
1997 *Communication Arts* and
the *American Photography*
annual. He also teaches at the
prestigious Santa Fe
Photographic Workshops.

pp: 153

photographer **Isak Hoffmeyer**

address Isak Hoffmeyer
Ryesgade 3
2200 KBH N
Denmark

agent Charlotte Morgan

address 1st Floor, 62 Frith Street
London W1V 5TA
England

telephone +44 (0)171 734 7511

fax +44 (0)171 734 6114

biography I've been shooting for myself
for the past 3 1/2 years and
have worked in Denmark,
England and Sweden.

pp: 109, 128

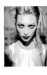

photographer **Marc Joye**

studio Photography BVBA

address Brusselbaan 262
1790 Affligem
Belgium

telephone +32 (53) 66 29 45

fax +32 (53) 66 29 52

agent (Japan) Mitsuo Nagamitsu

telephone (30) 32 95 14 90

agent (France) Maryline Kopko

telephone (1) 44 89 64 64

biography Photographing on Sinar 4x5in
and 10x8in, Marc prefers
arranged set-ups both in the
studio and on location. He
finds it most exciting to create
effects directly on
transparencies.

pp: 99

photographer **Wher Law**

studio Wher Law Photography

address Workshop 412
Chai Wan Industrial City,
Phase II, 70
Wing Tai Road
Chai Wan, Hong Kong

telephone (852) 2516 6511

fax (852) 2516 6527

e-mail wher_law@hkipp.org

URL www.hkipp.org/wher_law/
home.htm

biography Wher Law, a young renowned
fashion & advertising
photographer, crazy on
alterative music / movie, my
literal flavour greatly
influences the working style
and open minded searching
new version of the perfection.

pp: 22

photographer **André Maier**

adress 104 Suffolk Street, 12
New York, New York
USA 10002

telephone (212) 254 3229

fax (212) 254 3229

e-mail andre@andremaier.com

URL www.andremaier.com

biography German photographer Andre
Maier has studied professional
photography at the London
College of Printing in England,
and now lives and works in New
York city. His diversity in style
– from photojournalism to
fashion and conceptual
portraiture – has earned him
numerous exhibitions in Europe
and New York. He is now
concentrating on expressing
creative ideas and concepts
through carefully planned
makeup, original sets and
computer retouching His clients
include record companies,
magazines and ad agencies.

pp: 76, 31, 59

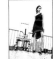

photographer	**Jeff Manzetti**
studio	Studio Thérèse
address	13 rue Thérèse
	Paris 75001
telephone 1	+33 (1) 42 96 24 22
telephone 2	+33 (1) 42 96 26 06
fax	+33 (1) 42 96 24 11
biography	Jeff Manzetti has been a

Jeff Manzetti has been a photographer for the past 12 years. His work took off rapidly, beginning with campaigns for international clients such as Swatch (worldwide), Renault, Lissac, Dior and L'Oreal, as well as many editorials for *ELLE* magazine. Jeff's work has always focused on beauty and personalities. His work has appeared as covers and spreads in *Figaro Madame, DS, Biba,* and *20 ans.* He has had the opportunity to photograph well-known celebrities such as Isabelle Adjani, Isabelle Huppert and Sandrine Bonnaire. His energy and humour extend to his work, as reflected in his advertising campaigns for Cinécinema and Momo's restaurant in London. He has also directed numerous videos and commercials in France, to great acclaim.

pp: 21, 37, 51, 57, 111, 119

photographer	**Renata Ratajczyk**
address	323 Rusholme Road, #1403
	Toronto, Ontario
	Canada M6H 2Z2
telephone	+1 (416) 538 1087
fax	+1 (416) 533 9569
email	renatara@ica.net
URL	http://www.virtualcolony.com/ renatar/
URL	http://www.lastplace.com/ EXHIBITS/CyberistHall/Renata/ catalog1.htm
biography	Renata is photographer and

Renata is photographer and digital artist. Her work includes fashion, fine art portraiture, as well as editorial, travel and advertising photography. She has developed a very painterly, imaginative, often surrealistic style She often enhances her work by a variety of techniques including hand-colouring and digital imaging. Her work has been published in a variety of magazines, on book covers, in calendars, on greeting cards and has been used for advertising. Renata has her own stock library and is represented by several stock agencies. Her studio is located in Toronto, Canada, but she also likes working on location.

pp: 71, 151

photographer	**Chris Rout**
address	9 Heythrop Drive
	Acklam
	Middlesborough
	Cleveland TS5 8QA
telephone	+44 (0)1642 819 774
mobile	0374 402 675
biography	A trained commercial diver at

A trained commercial diver at 21, Chris went on to train as an underwater photographer. He progressed into freelance photography eight years ago. A successful professional

photographer specialising in fashion and lifestyle stock photography, he is based in the north-east of England. Chris has his own studio and regularly takes commissions from magazines, advertising and commercial clients.

pp: 19

photographer	**Kazuo Sakai**
studio	Studio Chips
address	Daiei Building, 3F
	10-18 Kyomachi Bori 1
	Nishiku, Osaka
	550-0003 Japan
telephone	81 6 447 0719
fax	81 6 447 7509
biography	Born and raised in Osaka area

Born and raised in Osaka area of Japan. Has run the independent Studio Chips since 1985. Traditional photography since 1992, now uses both traditional and digital technology to achieve the final result.

pp: 85

photographer	**Craig Scoffone**
studio	Craig Scoffone Studios
address	P.O. Box 8426
	San Jose, California
	USA 95155
telephone	(408) 295 0519
fax	(408) 975 0519
email	csoff@best.com
URL	www.erotic-fine-art.com
biography	Craig Scoffone has been

Craig Scoffone has been producing top level photographic images for San Francisco Bay Area clients for

over 15 years. Besides producing innovative fashion images, Craig has also supplied many Silicon Valley based companies with excellent product photography services. Craig also has an on-line gallery at www.best.com/atcscoff/craig.html.

pp: 115, 127, 39, 95

photographer	**Bob Shell**
address	1601 Grove Ave.
	Radford, Virginia
	USA 24141
telephone	+1 (540) 639 4393
fax	+1 (540) 633 1710
email	bob@bobshell.com
biography	Bob is the editor of *Shutterbug*, the world's third largest monthly photo magazine, and is on the technical staff of *Color Foto*, Germany's major photo magazine. He has also been editor and publisher of a major UK photo magazine. His photographs and his writings about photography have been published in books and magazines all over the world, and he is the author of a number of titles on photographic topics.

pp: 105, 107, 69

photographer	**Antonio Traza**
address	8 St. Paul's Ave.
	London NW2 5SX
	England
telephone	+44 (0)181 459 7374
mobile	+44 (0)468 077 044
fax	+44 (0)181 459 7374
biography	Antonio Traza specialises in photography for advertising, editorial and design groups. His images include work in portraiture, fashion and fine art.

pp: 43, 45

photographer	**Gordon Trice**
studio	Gordon Trice Photography
address	774 E. North 13th Street
	Abilene, Texas
	USA 79601
telephone	+1 (915) 670 0673
fax	+1 (915) 676 4672
email	gordon@bitstreet.com
biography	Gordon Trice, 50, has been working in the editorial, advertising and corporate arena since 1968. His earliest experience was editorial. As a corporate staffer in aviation, he learned about various print media and graphic arts. He has worked for newspapers, wire services, magazines and corporations worldwide. His current work focuses on product photography in studio and on location.

pp: 66, 91

photographer	**Frank Wartenberg**
address	Leverkusenstrasse 25
	Hamburg
	Germany
telephone	+49 (40) 850 83 31
fax	+49 (40) 850 39 91
biography	Frank began his career in photography alongside a law degree, when he was employed as a freelance photographer to do concert photos. He was one of the first photographers to take pictures of The Police, The Cure and Pink Floyd in Hamburg. After finishing the first exam of his degree, he moved inot the area of fashion, working for two years as an assistant photographer. Since 1990 he has run his own studio and is active in international advertising and fashion markets. He specialises in lighting effects in his photography and also produces black and white portraits and erotic prints.

pp: 35, 49, 101, 103, 124, 142, 149

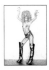 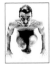
 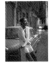

ACKNOWLEDGMENTS

First and foremost, many thanks to the photographers and their assistants who kindly shared their pictures, patiently supplied information and explained secrets, and generously responded with enthusiasm for the project. It would be invidious, not to say impossible, to single out individuals, since all have been helpful and professional, and a pleasure to work with.

We should like to thank the manufacturers who supplied the lighting equipment illustrated at the beginning of the book: Photon Beard, Strobex, and Linhof and Professional Sales (importers of Hensel flash) as well as the other manufacturers who support and sponsor many of the photographers in this and other books.

Thanks also to Brian Morris, who devised the PRO-LIGHTING Series, Simon Hennessey and Norman Turpin who made certain the books were as good as they could be, and Keith Ryan.